SOTHEBY'S

Guide to

Animation Art

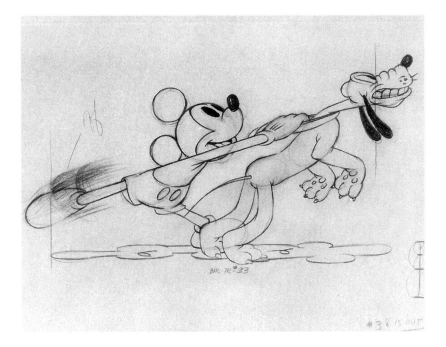

BAL TO #33

#38 IS OUT

SOTHEBY'S

Guide to

Animation Art

CHRISTOPHER FINCH

AND

LINDA ROSENKRANTZ

An Owl Book
Henry Holt and Company • New York

Henry Holt and Company, Inc.
Publishers since 1866
115 West 18th Street
New York, New York 10011

Henry Holt ® is a registered trademark of
Henry Holt and Company, Inc.

Sotheby's Books
New York • London
Director: Ronald Varney
Executive Editor: Signe Warner Watson
Specialist: Dana Hawkes, Vice President, Animation

Library of Congress Cataloging-in-Publication Data
Finch, Christopher.
Sotheby's guide to animation art / Christopher Finch
and Linda Rosenkrantz. — 1st American ed.
p. cm.
"An Owl book."
Includes bibliographical references and index.
ISBN 0-8050-4854-5 (pbk. : alk. paper)
1. Animated films—Collectibles—United States.
I. Rosenkrantz, Linda. II. Title.
NC1766.U5F56 1998
741.5'8'075—dc21 98-25113

Henry Holt books are available for special promotions and
premiums. For details contact: Director, Special Markets.

First Edition 1998

Designed by Kelly Soong

Printed in the United States of America
All first editions are printed on acid-free paper. ∞

1 3 5 7 9 10 8 6 4 2

CONTENTS

ACKNOWLEDGMENTS

Many people have been helpful in providing information and other input for this project. We would like to single out, at Sotheby's, Ronald Varney for starting the ball rolling, our editor Signe Watson Warner, and experts Dana Hawkes and Francie Ingersoll. Especially helpful at Disney were Tim O'Day and David Cleghorne, and at Warner Bros., Kay Salz, Kathleen Helppie, and Lorri Bond. And very special thanks go to Howard Lowery for providing us with such an informed and insightful history of animation art collecting.

I

COLLECTING
ANIMATION ART

1

The Rise of the Animation Market

While researching an earlier book, the authors were given access to what was known as the Walt Disney Studio morgue, a unique repository of animation art that was then stored in a nest of dungeonlike chambers beneath the Ink and Paint Department at the Burbank lot. Visiting this site in 1972 was like gaining privileged access to one of the world's great wine cellars. Stacked on metal shelves, the contents were covered with a fine layer of dust. Blowing this dust off the manila folders, you could discover vintage animation drawings, story sketches, and layouts from the Disney shorts of the 1920s, '30s, and '40s, not to mention from all the Disney animated features—from *Snow White and the Seven Dwarfs* to *The Aristocats*.

For anyone interested in animation, this was an incredible treasure trove. Yet, at that unenlightened time, exquisitely painted backgrounds from *Pinocchio* were casually rolled together and cels from all periods were left in unprotected

piles, the paint chipping off the acetate supports. One of the first folders we opened contained what appeared, at first glance, to be perfectly preserved animation drawings from a 1929 Mickey Mouse short. But when we picked up the top sheet it fell apart, and we were told that silverfish had penetrated some of the folders and eaten their way along the pencil lines.

Disorganized as the morgue appeared then, it had looked far worse barely a year earlier when, on the morning of February 10, 1971, the Sylmar earthquake toppled the wooden shelves on which the animation art had been stored for thirty years. Seeing this, one of the top executives of the company is said to have commented, "Why do we need all this stuff anyway? Let's get rid of it."

Luckily for the collectors and researchers of today, there were strong protests from archivist David Smith and from the Disney animators. Smith insisted that the material in the morgue had intrinsic value, and the animators argued that it was also important for research purposes and for training young artists. Eventually, a compromise was reached. One of the veteran animators, Eric Larson, was assigned the task of picking key films and sequences that he felt would be of particular value to the animation staff. The plan was to reduce the amount of "used" animation art to about one-third of the contents of the morgue and dispose of the remainder.

At the last moment, a decision was made to keep everything. Eventually all the surviving Disney art at the studio was re-housed in climate-controlled conditions, some in the archives, most of it in the newly established Animation Research Library.

This story is told to illustrate the point that, as recently as the early seventies, very few people—even those who derived their living from it—took animation art seriously. The situation

began to change rapidly, however. In 1973, a sale of primarily three-dimensional Disneyana at Sotheby's Beverly Hills auction rooms was an unqualified success. Other auctions followed and a handful of dealers specializing in animation art began to emerge. At about the same time, 1972–1973, the Collectors Bookstore in Hollywood, sensing there was a market for cels and other animation art, started to publish mail-order catalogues of such material and in 1978 initiated a series of mail and telephone auctions under the management of Howard Lowery. Upon the release of *Robin Hood* in 1973, the Circle Gallery in New York made an agreement with Disney to offer cels from that film, the beginning of an approved art gallery program that, although it has changed and expanded over the years, is still in effect.

It was in 1984 that the first animation sale—that of the collection of former Disney employee John Basmajian—was held at Christie's, initiating a pattern of regular sales at both Sotheby's and Christie's. This, combined with a resurgence of quality Disney feature animation, the availability of vintage films on video, and a wave of nostalgia on the part of Baby Boomers for their cartoon-rich past, produced a groundswell of collector interest and a burgeoning animation art market. By the late 1980s, animation galleries had become commonplace in malls and shopping centers across the country and auction highs were being featured regularly on television newscasts and in newspapers and magazines.

IN REALITY, OF course, there had always been a handful of hardcore animation collectors, many of them animators or people with ties to the industry. From the days of Winsor McCay's *Gertie the Dinosaur* (see Chapter 5), the public had been fascinated with animated films and with the artistry that goes into their creation. No doubt artists who worked at the major ani-

mation studios of the silent era—those employed by Max Fleischer, Paul Terry, Pat Sullivan, and other pioneers—took work home with them, some of which has been preserved.

The success of the Disney Studio, starting with the debut of Mickey Mouse in 1928, helped make animation art more desirable, even if cels and such were looked on as souvenirs rather than as artworks with intrinsic value. Walt Disney himself was certainly conscious of the fact that the production art that went into the making of his films had worth, and he made sure that his ownership extended to every scrap of paper scribbled on at the studio. Even so, his artists did take drawings home, a practice Disney seemed to have turned a blind eye to so long as there was no intent or effort to sell them. It was also commonplace for animators to exchange work with one another and in that way to build up comprehensive collections—some of which have since reached the marketplace.

Walt Disney and his brother Roy were in the habit of presenting pieces of animation art to visitors to the studio. They appeared to have discovered early on that these visitors were especially taken with cels, or cel and background setups, as opposed to the animator-collectors, who preferred preliminary drawings and other works on paper, such as story sketches and layouts. A small number of cels, then, were preserved specifically as giveaways. Most Disney cels of the thirties and early forties, however, were simply cleaned with solvent and reused. (Cels can always be reconstructed so long as the animation drawings and art direction information has survived.)

Starting in 1937 and continuing until 1946, the Courvoisier Gallery in San Francisco entered into a licensing agreement with Disney to offer the public production cels in matted setups with non-production backgrounds. This marks the earliest attempt to market animation art as material of intrinsic value, and its rise corresponded with the rise of the Disney ani-

mated feature film (though many Courvoisier setups featured Mickey and other characters from the early shorts).

After World War II, and the cessation of the Courvoisier program, Disney animation entered a relatively fallow period which lasted for several years, and collector interest seems to have waned until the opening of Disneyland in 1955. As is often fondly remembered by today's collectors, visitors to the park's Tomorrowland Art Corner could purchase cels from first, *Lady and the Tramp*, and later, *Sleeping Beauty, 101 Dalmatians, The Jungle Book*, and other films, some of them bearing Walt Disney's signature. Marketed as Disneyland mementos, they were priced from $1.25 and up, no more than the purchaser would have paid for a Mickey Mouse T-shirt. Thus, between 1955 and 1970 thousands of cels from these films were acquired by members of the public—more as souvenirs than as objects of collectible art. This well may have helped restore grass-roots interest in animation art, even though the low prices tended to trivialize it at the same time.

If there was only modest interest in collecting Disney animation art prior to the 1970s, there was even less in the products of other studios such as Fleischer, Walter Lantz, and Terrytoons. Even the products of the formidable animation departments of Warner Bros. and MGM were ignored. A new generation of collectors was emerging at about that time, however, one that took Disney animation very seriously but was also tuned in to the hipper style practiced at Warner Bros. and MGM. It was intense interest in the Disney classics that led to the development of the present market in animation art, but soon work from the great comedy shorts directed by men such as Tex Avery and Chuck Jones was becoming highly prized as well. Eventually, even cartoons created for television by companies like Hanna-Barbera would attract the attention of collectors, and with the renaissance in feature animation today, it

can only be assumed that all these fields of collecting will continue to expand in the future.

We are dealing, then, with a very new field of collecting, one that has risen to prominence entirely within the past quarter-century. Activity within that period, however, has been so intense that the field already has a significant history with a large body of unknown work having emerged to public view from the attics and cabinets where it had been stored for decades. Great collections have been built and dispersed, to be replaced by new ones. Although scholarly books, articles, and catalogues have been produced, animation is still a fresh collecting area where everyone is welcome and snobbery is largely unknown.

Best of all, if you've ever attended a Bugs Bunny festival, or rented the video of *Dumbo*, you've already taken the first step toward becoming an expert.

2

WHAT IS ANIMATION ART?

Animation art is a term used to describe any of the many forms of artwork that are involved in the making of an animated film. The example best known to the general public is the cel—a painting of a character or characters made in opaque color on transparent acetate. The cel is often mounted and framed with a background to create a cel setup that provides a complete image, such as you would see on a motion picture screen.

Cels and cel setups are, in fact, the final products of the art of animation and they come into existence only after a number of other artists have had input into the creation of any given frame of film. Given that there are as many as 75,000 frames in an animated feature like *Beauty and the Beast*, it will be seen that an incredible number of individual pieces of artwork—ranging from rough sketches to highly finished paintings—go into the making of an animated film.

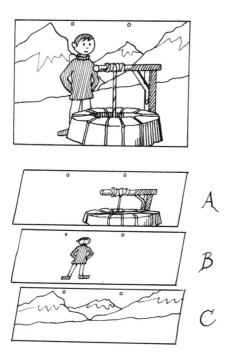

Even a relatively simple cel setup such as this one at the top involves three distinct levels of imagery. A is a static foreground element painted on a transparent cel. B is an animated character painted on a transparent cel. C is the background painted on a sheet of paper or art board.

In the classic style of animation, which evolved in the 1920s and 1930s and reached maturity with the first Disney features, a film goes through the following basic stages of production. Once a subject has been decided on—let's say it's the nursery rhyme "Jack and Jill"—a small group of artists and writers are brought together to begin to conceptualize the story. What does Jack look like? Is he a kid or a teenager? Is Jill his sister or his girlfriend? Sketches begin to be made of the characters and the process of accumulating artwork has begun. Along with these basic character concepts, other artists begin to visualize the setting in which the movie takes place. Is the hill Jack and Jill climb a little hummock or is it a snow-capped mountain? If they have to climb a mountain, what kinds of perils might they face? Answering these questions may lead to drawings and even detailed paintings of Alpine precipices, glaciers, ravines,

and avalanches. Pre-production art of this sort is often referred to as "concept art" or "inspirational art." It will not appear in the finished film, but it may well help determine what finally appears on the screen.

Meanwhile, story artists will be discussing the narrative. The nursery rhyme itself is somewhat minimal when it comes to plot development. If an interesting film is to be made, we must know *why* Jack and Jill went up the hill. To fetch a pail of water, yes, but more detail is necessary. Was the water needed to put out a fire? And if so, how did the fire start? Or is the plucky couple fetching water to quench somebody else's thirst? If so, who is the recipient of their generosity? Or are they on a quest to win back a pail of magic water stolen by the Abominable Snowman who lives on top of the mountain? As the story begins to take shape, it is laid out in the form of thousands of individual sketches pinned to dozens of storyboards, each representing a sequence in the movie. (This is in the case of a feature film. A short may require just a single storyboard.) Some of these sketches will be discarded. Others will be used to tell the final version of the story. In any case, all of them are part of the production process and all of them have value as animation art.

As the narrative takes shape on the storyboards, a script is written, dialogue is recorded, and often a story reel—sometimes called a pose reel—is produced, this being a piece of film or video in which story sketches are matched to the recorded dialogue and sound effects to give a crude sense of what the viewer will see in the final version. By this stage, art directors and/or production designers are likely to be working on more detailed versions of the various settings—deciding not only what a given landscape or interior will look like but also how it will be lit in particular scenes. Often the paintings and drawings produced at this stage are very dramatic, emphasizing the mood and action of the situation portrayed.

By now the time has come to begin mapping out scenes in more precise detail. Clearly it is no simple matter to put together a scene in which several characters may have to interact with one another as well as with inanimate objects of various kinds. To portray just a single character crossing a room requires careful planning. In our imaginary film, when Jack sneaks through the Abominable Snowman's lair, there are moments when he passes in front of pieces of furniture, partially hiding them, and moments when he passes behind pieces of furniture, so that they partially hide him. All of this must be laid out in detail before animation can begin. In a more complex scene, such as one in which Jack and Jill are chased over a frozen waterfall by the Abominable Snowman and his ice warrior minions, the planning can become enormously complex.

CAMERA PANS WITH JACK & JILL AS THEY CLIMB THE STEEP MOUNTAIN PATH.

GOAT FOLLOWS J & J

Layout drawings provide basic information that is needed by the animator, the background artist, and the camera operator. They are diagrams of scenes in which the setting is established and camera moves are indicated in schematic form, along with the movements of animated characters.

The layout artists who are responsible for this phase of production create some of the most beautiful and least appreciated examples of animation art. At times their drawings are quite large because they have to accommodate the complete sweep of complex camera movements. If the camera is to follow Jill as she walks the length of a city block, that entire block must be shown in a single drawing that may be long and narrow, like a Chinese scroll. These drawings are often very precisely rendered, since they will serve as a guide to both animators and background artists. The layout drawing is the template of the scene through which each animated character must move. It shows the exact placement of rocks and trees, or tables and chairs, so that the animator can see where the character must go. And it is a template for the background artist as well. Misplacing a single rock by a fraction of an inch could totally ruin the scene.

This is not to say that the background artist's role is entirely mechanical. The layout drawings give him the outlines he must work with, but he still needs considerable skill in rendering. Often, too, the background artist is involved with producing what are sometimes called color keys—looser, freehand paintings intended to establish the color and the mood for a given set of related backgrounds.

Like the background artist, the animator cannot begin his or her work until the layouts have been established. Even an effects animator, creating lightning as Jack and Jill are caught in a storm, must be aware of exactly how the scene is to be staged so as to know where the bolt of lightning should strike. Effects animation can be important in establishing mood, but most of the (deserved) credit goes to the character animators who bring Jack and Jill and the Abominable Snowman to life. Their skill, which extends far beyond an ability to draw well, is central to the making of animated films. A good animator must be a

skilled draftsman who can breathe life into his drawings. He has been described as an actor with a pencil, one who can visualize how his character—say Jack, running with the pail of water—will move on-screen, even though it may take him several days to create the drawings for just a few seconds of film.

The animator works on sheets of semitransparent paper that are held in place by a system of pegs and punched holes over a light board set into an animation desk. When an animator begins a new drawing, he places a blank sheet over the previous drawing which shows through faintly, helping him match one drawing to the next. In the Disney system, the top animators draw the key poses—the moments that define, for example, the way a character walks. These are among the jewels of animation art and their creators are the stars of the animation world.

A top animator's contribution may amount to one drawing out of every four that is needed for a particular sequence. The intervening drawings are made by an assistant, known as an in-betweener. Because the character animators do not have the time to finesse their work, these drawings are often called "ruffs" and they are handed on to cleanup artists whose job it is to give them their final crisp outlines. In the past this often meant literally cleaning up the ruffs. Nowadays, however, cleanup artists actually trace the ruffs and make completely new, polished drawings.

From this it can be imagined, then, how many thousands of animation drawings are involved in making a feature-length movie, especially since some scenes require the combination of several in every frame.

In the traditional system—used at Disney until *The Little Mermaid* and still in use elsewhere—these animation drawings were sent to the Ink and Paint Department where they were turned into camera-ready art. There the outlines would be

A pan background is an elongated background painting
that permits the camera to follow animated characters,
without cuts, along the length of a city street, for example,
or through any other kind of extended environment.

traced onto sheets of acetate then painted to create cels. (In the 1960s, xerographed lines began to replace the inked ones.) The acetate sheets were held in register by a system of pegs and holes matching that used by the animators. The completed cels were passed on to the camera department where they were shot, one frame at a time, in conjunction with the appropriate backgrounds in order to create the finished film.

Since *The Rescuers Down Under*, however, Disney has used a computer—the so-called CAPS system—to replace the ink and paint and camera phases of production (see box page 18). All character animation drawings and almost all backgrounds are still drawn or painted by hand, but no cels are involved because the cleaned-up drawings can be scanned directly into the computer, where they can be colored electronically and combined with the backgrounds.

Because of the demand for cels—both for collectors and as an in-house record—Disney has continued to produce a limited number of cels and cel setups from each of its recent features. These cels are not used in making the actual film, but they are combined with genuine production backgrounds. The majority are consigned to Disney's Animation Resource Library, but

examples from most of the CAPS-era features have been made available at auctions organized in conjunction with Sotheby's.

THERE ARE, THEN, many kinds of animation art, but it is safe to say that anything likely to be of interest to the general collector falls into one of three categories. The most popular with collectors is camera-ready art, which includes cels and backgrounds and the various forms of setups in which these are combined. This category comprises not only the artwork that is actually recorded on film when an animated movie is made but has been expanded to include what *appears to be* camera-ready art, although it has actually been prepared with the collector rather than the camera in mind. Included in this group are the Courvoisier setups already mentioned, as well as the special editions of cels and setups put out in recent years to celebrate current Disney films in which cels were replaced by computer technology.

Camera-ready art affords the collector the opportunity of owning something that is very close to what appears on screen. At the same time—with the exception of production backgrounds—it does not represent the handiwork of the artists who created the movie but rather the craftsmanship of the ink and paint technicians whose job it was to trace animation drawings onto acetate and color them in.

A second classification of animation art comes under the general category of production art. This consists of all the artwork—inspirational and concept paintings, model sheets, story sketches, layout and animation drawings, etc.—that are involved in the creation of a movie *before* the various elements are converted into camera-ready art. It is in these drawings and sketches—some magnificently detailed, some mere scrawls to the uninformed eye—that you will find the signature draftsmanship of the gifted men and women who give animated

films the life and energy that attracts us to them in the first place. If cel setups are the oil paintings of the animation art world, production art has the freshness of preliminary studies and watercolors, and as such often reveals much more of the personality and spirit of the artist. Not surprisingly, it is this kind of pre-animation art that is most prized within the community of animation artists themselves. On the other hand, a fine animation drawing or story sketch is in general still far less expensive than a cel setup from the same movie, and it is the authors' opinion that production art of this kind is often overlooked and almost always undervalued.

An unusual kind of production art, one that almost amounts to a category in itself, is made up of the three-dimensional figures, usually sculpted from plaster or clay, that are used by some studios—notably Disney—to provide their animators with character models in the round. These should not be confused with the figurines that are sometimes produced in editions after a movie has been released. Though often attractive, these figurines are not true animation art.

The third category of animation art collectibles comprises

Storyboard sketches are rough drawings made by artists in order to develop the narrative of a movie in visual terms.

various peripheral and miscellaneous kinds of artwork, such as promotional material featuring cartoon characters. Posters and lobby cards, for example, make extremely attractive collectibles.

This book will be concerned primarily with the first two categories of animation art. We will outline the history of animated film and provide information on everything from what to look for to how to care for your collection.

Special Editions and One-of-a-Kinds

Beginning with *The Rescuers Down Under* in 1990, the Disney Studios inaugurated a sophisticated, Academy Award–winning computerized production system, known as CAPS (Computer Animation Production System) for use in its animated features. This system does not generate animation but allows handmade drawings to be copied, colored, and combined electronically with a painted background. Since it produces finished imagery that can be electronically transferred directly to film, frame by frame, the need for cels is thereby eliminated. That being the case, there are no actual production cels in existence for any Disney feature made after 1990, and collectors should be aware that all post-1990 Disney cels were produced specifically for the collectibles market.

Actually, Disney had had a formal limited editions program in place since 1973 when the Disney Art Editions program was established. In 1974, four handsome portfolios, covered in velvet and taffeta, were released in editions of 275 copies. These contained specially produced hand-inked and hand-painted cels with images from *Snow White, Pinocchio, Cinderella,* and *Lady and the Tramp.* There was then a gap of several years until the Disney Art Program was initiated to develop xerographic-line limited edition cels, beginning with a two-cel set from *Song of the South.*

In 1996, Disney announced the formation of a new fine art division, Walt Disney Art Classics, essentially a merger of two existing units—Disney Art Editions, publishers of Walt Disney Studios Art, and Disney Collectibles, creators of the Walt Disney

Classics Collection. The new division assumed responsibility for presenting an annual auction of original, one-of-a-kind artwork from contemporary Disney animated films. This program, starting with the sale of pieces (hand-painted cels married to production backgrounds) from *Who Framed Roger Rabbit* in 1989, has been a collaboration with Sotheby's auction house, and the 1995 sale of artwork from *The Lion King* fetched two million dollars, setting a record for the highest-grossing animation auction in history. These contemporary auctions tend to draw quite a different audience from those of vintage animation art. The latter category is apt to be made up of more committed collectors, interested in historical and aesthetic value, while the former is made up more of collectors interested in obtaining attractive setups that they can frame to match precisely the film images they see on their video players.

Under this program, Disney creates cels for the entire film, not just for the auctions but for its own animation library and for special exhibits. Every cel and background is carefully examined by Disney experts with an eye toward what should be kept and what should be auctioned, often a difficult decision in terms of the key moments of a film. Approximately one-quarter of the cels are offered at auction, as are 30 percent of the backgrounds.

Each limited edition in the Walt Disney Studio Animation Art portfolio bears a seal and is accompanied by a certificate of authenticity. Three main types of special editions are on the market, which, in the case of Disney, all begin in the Ink and Paint Department. They are:

Hand-inked limited edition cels: These are made using traditional animation techniques, which include tracing an animation drawing onto acetate by hand, using different colored inks, and hand-painting it with specially formulated gum or acrylic-based colors. Most hand-inked cels are combined with backgrounds, a small number of them hand-painted presentation backgrounds. Hand-inked and painted cels, released in editions ranging from 275 to 350 are the most expensive of the limited editions.

Xerographic-line limited edition cels: Instead of being hand-inked, these are created by transferring the outline of the original animation drawing to the acetate cels by a six-step xerographic

process pioneered by Disney in the 1950s. Many of these cels are then enhanced with hand-inked lines before being hand-painted and combined with a lithographic background.

Sericels: The least expensive form of limited edition artwork is the serigraph, or sericel. To produce these silkscreens, artists create a hand-inked, hand-painted color model of animated characters, which is then transferred to the acetate cel by a silkscreen printing process known as serigraphy. The sericel is usually sold without a background and in considerably larger numbers (1,000 to 5,000) than the others. Among the many Disney sericels that have been made available are images from *Snow White and the Seven Dwarfs, Pinocchio, Fantasia, Winnie the Pooh, Jungle Book, The Lion King,* and *Alice in Wonderland.*

There are other, non-Disney special editions now on the market as well. Several distinguished veteran animators, including Chuck Jones and Friz Freleng and the estate of Bob Clampett, have manufactured new artwork based on their vintage cartoons and with the authorization of the studios concerned. These have been released in editions ranging from 100 to 1,000 through various art galleries and animation dealers. They come with reproduction—not hand-painted—backgrounds, produced either by color xerography or lithography.

Warner Bros. has created a gallery program that is part of the studio store system selling original animation art and limited edition cels and sericels. The artwork offered from *Space Jam* and *Quest for Camelot* is all hand drawn and placed against painted backgrounds. (Since *Space Jam* contained only fifteen minutes of animation, there were only 350 backgrounds created, as compared to the 1,200 or so in a typical animated feature.) As with Disney, the Warner cleanup drawings are digitized and then electronically inked and painted, not by the CAPS system but with another computer animation program called ANIMO, developed by Cambridge Animation Systems.

3

WHAT TO LOOK FOR
IN ANIMATION ART

You walk into an animation art gallery or auction exhibition and see two seemingly similar animation cels on display side by side. They are both colorful and cute. So why does one have a price tag (or estimate) of $900 and the other $9,000? In this chapter we will outline the various factors that go into the configuration of the price structure of the animation market.

Before we get into specific factors, however, we would like to pass on two more general guidelines when it comes to buying this category of artwork—or any other—advice that has been repeated over and over by every expert we interviewed for this book. They are:

1. Buy what pleases you, not what you think will be a good investment. In a volatile market, there is no certainty of any piece appreciating in value; indeed, some cels that reached astronomical highs in the inflated

1980s have now settled down to a more realistic level. On the other hand, if you buy something you love, and care for it properly, chances are it will continue to hold the same appeal for you in the future.

2. Educate yourself. Learning as much as you can about the field, both from a technical and historical point of view, by reading books (the Bibliography at the end of this book will point the way) and going to every auction and gallery you can, paying particular attention and inspecting the items at the presale exhibitions, will not only make you a more informed collector, but enrich your enjoyment of your possessions. Auction exhibitions in particular usually offer a large diversity of work from various studios and periods, representing all stages of the animation process available for close-at-hand perusal.

In response to the question, "What would you recommend to a novice collector who walked into your gallery?" the highly respected animation dealer and auctioneer Howard Lowery replies, "I would go over and get one of the books that we sell off the shelf and say, 'Here, buy this book for $19.95, take it home and read it. After you've read the book, go down to the video store and rent five [animated features or compilations], any five, and watch them on your VCR. Come back to me a week later and tell me which characters you like, what you're interested in, if you want the cels you see on the screen or if you're more interested in the story art that someone created in the development of *The Old Mill*.' You must do your homework no matter what you do. It's the only sensible approach."

Clearly there is no substitute for knowledge and common sense, and the more of each a collector possesses the more

rewarding in every sense his acquisitions are likely to be. It is a mistake to think that consistently wise choices can be made by following a rote set of formulae. At the same time, it should be recognized that certain factors do tend to raise or lower prices, some more obvious than others.

CONDITION

In general, top prices are brought by cels and drawings that are in the closest to pristine condition, but some of the small imperfections of age should not necessarily be regarded as major prohibitions. For example, some very old cels may appear wrinkled because of shrinkage of the celluloid, yet they will remain highly desirable to serious collectors because of their rarity. Things to be aware of are cel paint that is cracking or missing in places, faded or light-damaged. In works on paper, check for folds, tears, or tape marks. All these defects can affect monetary value, though some can be satisfactorily restored.

Be sure to examine carefully any piece you are considering purchasing—you cannot depend solely upon a catalog description, since items are often catalogued several months before a sale, during which time there might be additional spotting, splitting, or separation on a cel. Absentee bidders in particular are advised to call the dealer or auction house and discuss the condition just prior to sale. A reputable dealer or auction house expert will be glad to give you the information you need on which to base your decision.

The fact that a cel has been trimmed—cut from the original surface and affixed to another cel—should not lessen the value, so long as the work has been done carefully. This practice became commonplace during the late 1930s when the Disney Studio began preparing cels for sale by the Courvoisier Gallery.

Since that time it has often been used for presentation setups—cel setups intended as gifts for VIPs or for sale to the general public.

COMPLEXITY

As a general rule of thumb, the more original components there are in a cel setup, the more valuable it will tend to be. Different characters are often painted on different cels. Imagine, for example, a setup from *Snow White and the Seven Dwarfs* that involves the title character, Dopey, and several forest creatures. Snow White might be on one cel, Dopey on another, the animals on a third. In addition there will be the background, painted on paper, and possibly an overlay cel on which has been painted a static item, such as a tree trunk or a chair. This would be a good example of a complex cel setup, rich both in terms of the number of characters involved and the number of production elements.

POSE AND POSITION

This is an area in which some experts offer highly specific guidelines, some of which are listed below, although it is our opinion that such hints are of limited use at best. As the collector becomes more familiar with animation art, he will come to judge quality by more subjective standards based on experience, and he may even come to recognize the work of individual animators who have made special contributions to the medium. For a beginner, though, it may be helpful to have these guidelines, understanding, of course, that they hold only when all other factors are more or less equal, and should not be taken as iron-clad rules.

1. A full figure is more desirable than a partial one, just as a full-face presentation is seen as superior from a collecting point of view to a profile.

2. A pleasant or smiling expression on the character's face is preferable to an unpleasant one.

3. Open eyes are considered an advantage over closed ones.

4. Cuteness counts.

5. When the character is positioned near the center of the cel rather than off to one side, this can positively affect its value.

CHARACTERS

Certain characters have endeared themselves to the public to the point that collectors are willing to pay a significantly higher price to possess a depiction of their image. According to Francie Ingersoll, the specialist in charge of Sotheby's animation auctions, one example is Dopey, who far outshines all the other dwarfs in *Snow White* when it comes to auction prices. The mischievous little guy is worth double what his roommates command. Other particular Disney favorites of collectors range from Mickey Mouse to Thumper to Briar Rose from *Sleeping Beauty,* Pinocchio, Jiminy Cricket, Maleficent, Cruella DeVil, Jessica Rabbit, Winnie the Pooh, and Ariel in *The Little Mermaid.* Favored characters from other studios include Bugs Bunny, Daffy Duck, Tweety and Sylvester (preferably on the same cel), Wile E. Coyote and Road Runner, Red Hot Riding Hood, Popeye, Snoopy, and Fred Flintstone. Needless to say, the key characters in a film will be more desirable than some

obscure secondary figure and, generally speaking, heroines and villains are more highly prized than the prince charmings and other heroes.

All of this will be discussed in detail in the historical section of the book.

FILMS

Just as some characters are particular favorites, so is the artwork from some movies more in demand than others. Usually, but not always, this is related to how well the film did in theatrical release and on video. So, while pieces from *Snow White and the Seven Dwarfs, Pinocchio, Fantasia, One Hundred and One Dalmatians,* and *Lady and the Tramp* tend to be extremely popular, fine examples of the art of animation from such films as *The Sword in the Stone* or *Robin Hood* might prove to be bargains on the marketplace.

Where studios other than Disney are concerned, this rule of thumb is less clear-cut. Original animation artwork from Warner Bros., MGM, UPA, and other important producers is so rare—most of it was destroyed—that any good example of a key character is valuable, no matter which movie it is from. Even so, a setup from a Warner Bros. classic like *What's Opera Doc?* would be more valuable than a setup from a routine Bugs Bunny vehicle. (A "Historical Importance" list follows later in this chapter.)

SIGNATURES

The Walt Disney Studios once employed several artists and assigned part of the secretarial staff to affix a "studio" signature to all animation setups given away, and these will add approximately $200–400 to its value. In the rare cases when there is a

genuine signature by Walt Disney himself, the figure rises to from at least $1,000 to $1,500 over the normal cel price.

Pieces from any studio signed by animators, background artists, or directors secure premium prices, even if the autograph has been signed recently rather than at the time of production.

At both Warner Bros. and MGM, some cels and setups released to the public during the studios' heydays were furnished with screen-printed guaranties of authenticity in the hand of the studio head (Leon Schlesinger at Warner's, Fred Quimby at Metro). These have some value since they do provide a provenance.

Disney limited editions do not usually bear hand signatures, but all those from Warner Bros. and Hanna-Barbera do. In all cases, be on the lookout for reproduction signatures and try to get authentification.

SCARCITY

Since so few are known to exist, cel setups from the black-and-white era represent some of the most desirable material to collectors. As a rule, older cels will be more expensive because of their rarity.

Pan backgrounds—elongated paintings that show broad panoramas (and therefore permit camera pans) have always been rarer than standard-size ones, and prices can be figured at roughly one and a half to three times more, given comparable quality.

Again it should be emphasized that at most studios cels were either reused or destroyed. Because Disney was the studio that received the most attention from the media and the public, its animation art was valued more highly and so more of it has survived, relatively speaking. Really first-rate material

from Warner Bros. or MGM, therefore—especially pre-1945 material—is much scarcer than comparable Disney material. For the time being, Disney's prestige compensates for this when it comes to prices, but this could change in the long run.

HISTORICAL IMPORTANCE

Landmark films in the history of animation, either because of some technical innovation or the introduction of a major character, as well as key plot scenes in a movie have a special weight in the marketplace. A few of these milestones are:

Steamboat Willie, 1928	First animated sound short, Mickey Mouse debut
Dizzy Dishes, 1930	Betty Boop debut
Mickey's Revue, 1932	Goofy's debut
Flowers and Trees, 1932	First color short, first Academy Award–winning cartoon
The Band Concert, 1935	First color Mickey
Popeye the Sailor, 1933	Popeye's debut
The Orphan's Benefit, 1934	Donald Duck's major debut
Snow White and the Seven Dwarfs, 1937	First animated feature
I Haven't Got a Hat, 1935	Porky Pig's debut
Porky's Duck Hunt, 1937	Daffy Duck's Debut
Porky's Hare Hunt, 1938	Bugs Bunny debut
Puss Gets the Boot, 1940	Tom & Jerry debut

PROVENANCE

Provenance is a word meaning source or derivation. When we talk of the provenance of a work of art we are asking questions such as "Who owned this work before?" and "How do we

know where it came from?" With luck, the answers will help tell us whether or not the work is genuine.

For example, Disney cels with Courvoisier backgrounds were marketed from the late 1930s to the early 1940s, can be easily identified, and have a special cachet that translates economically into increased value. Look for the Courvoisier Gallery's standard labels and seals (see box).

Signatures are a useful guide to authenticity, but keep in mind that if someone is skillful enough to fake an animation drawing they are certainly skillful enough to fake the artist's signature.

Always find out as much as you can about how an item you are interested in purchasing came to be offered for sale in the first place. Let's suppose a group of cels was brought to an auction house by the estate of an artist who worked at, say, MGM at the time those cels were produced there; this is a pretty good guarantee that the cels are authentic.

If you come across animation art that is in an old frame, it pays to inspect the back of the frame for labels that may tell you something about the image's past history. If the work has been lent to an exhibition, for example, it may be recorded on the back of the frame, and the exhibition catalogue may illustrate the work, thus enhancing the provenance. The fact that an image has been reproduced in a reputable magazine or book also helps establish provenance.

When buying from a dealer, make sure the cels being offered are from the original classic films and not from some more recent television presentation based on the original. For example, Disney produced four featurettes starring Winnie the Pooh, but the same characters, drawn in much the same way, appeared in many episodes of a television series. Setups from the television shows are not totally without value, but setups

from the featurettes (especially the first three) are worth far more.

Most creditable galleries will provide their own certificate of authenticity. If a dealer balks at providing such a certificate, take your business elsewhere.

It cannot be repeated too often that ultimately it is the buyer's taste that is most important in making purchases of this kind. On the other hand, nobody wants to find that they've bought something that was not what it was represented to be or that they've paid twice what something is worth. The golden rule, then, is: Buy from a reputable dealer or auction house and do enough research to be sure that you know what you're looking at.

The Courvoisier Program

Looking through an animation art catalogue, you may come across the phrase, "Courvoisier setup," and wonder just what that means. The prehistory of the Courvoisier program goes back to 1905, when a man named Ephraim Courvoisier opened an art gallery in San Francisco, one that would enjoy long-running success. By 1937, the year Walt Disney released *Snow White and the Seven Dwarfs,* Ephraim's son Guthrie was running the gallery and, searching for something novel to offer his clients, approached the Disney brothers, Walt and Roy, with the idea of making animation cels commercially available to the public. This proposal resulted in the formation, on July 19, 1938, of a licensing agreement between Walt Disney Enterprises and Courvoisier that enabled Courvoisier to offer cel art through his Geary Street gallery. Beginning with pieces from *Snow White,* Courvoisier thus became the first licensee authorized to sell Disney material, and Guthrie Courvoisier became the first person to recognize both the aesthetic value and commercial potential of animation art.

The key person at the Disney end of this collaboration was Helen Nerbovig. A graduate of the Disney training program and member of the Ink and Paint Department, one of her hobbies was

making greeting cards for friends by taking cels and assembling them against backgrounds she devised using airbrush techniques and decorative papers. When these cel setups caught the eye of Walt Disney, he knew he had the perfect person to supervise the production of cels to be distributed by Courvoisier. Under her direction, a special twenty-artist unit was set up at the studio to prepare the artwork, cutting out characters from existing cels and applying them to a background. Since there are so many more cels than backgrounds in a film—the same background appears in frame after frame with different action taking place against it—they could not rely upon existing backgrounds and had to create their own.

To produce a unique background for each piece, the Disney artists used a variety of art boards and hand-rubbed wood veneers and cut stencils for background elements evocative of the film, or set off individual characters in vignettes. They also used the original cel overlays and special effects to enhance their setups. The program was enormously successful and by March of 1939, 8,136 cels, 150 backgrounds, 206 story sketches, and 500 animation drawings from *Snow White* alone had been consigned to Courvoisier, as well as almost 5,000 cels from other Disney films.

Preparing the setups at the Disney Studio was getting to be an expensive proposition, however, so in April 1939, Roy Disney, the business head of the firm, suggested that the art provided for sale after *Pinocchio* would be done in-house by Courvoisier. The gallery then hired local college students to prepare the setups, at which point the elaborate wood veneers and stenciled backgrounds became a thing of the past, replaced by schematic chalk and pencil backgrounds. Lacking a staff skilled in cutting out the characters and other techniques, Courvoisier began to laminate the cels in a rigid, high-temperature envelope to prevent the paint from peeling off—an unfortunate decision, as it often led to warping.

All in all, the program continued for eight years, ending in September of 1946, when the gallery closed. The Courvoisier Gallery had offered art from five features and thirteen shorts, an estimated 15,000 to 20,000 pieces in all, and had produced, particularly in the early days, some of the finest pieces of vintage animation art that can be found today. Fortunately, it is not difficult to identify.

In their original condition Courvoisier setups usually possess the following features: a non-production background and a cream-colored mat with the character name and/or the title of the film. There will also be the letters "WDP" penciled below the mat opening, as well as an encircled "WDE" written in pencil and an encircled "WDE" or "WDP" embossed or stamped on the mat and/or background. (WDE—Walt Disney Enterprises—indicates that the setup was made before 1939 when the corporate name was changed to Walt Disney Productions.)

The setups made at the Disney Studio usually have two small labels on the back, one reading "Copyright/Handle with Care," the other denoting the title of the film, either printed or hand-written. Backs were sealed using a special colored paper, and a white label was added stating the provenance of the piece. When the art began to be prepared by Courvoisier, they added a small "Original WDP" seal, rubber-stamped at the lower right corner of the mat opening, and a similar seal on the background. Since Courvoisier distributed art to other galleries, there might also be the label of a local framer or gallery as well.

4

STARTING AND BUILDING
A COLLECTION

In the most literal sense of the phrase, starting a collection of animation art is easy. You are out shopping one day and you are attracted by the cels in the window of the local animation art store. With a little time on your hands, you step inside and spot something that catches your attention. It's a framed image of Bugs Bunny, let's say. A casual inquiry elicits the information that the image comes from a limited edition of cels authorized by Warner Bros. The price proves to be more reasonable than you had expected and ten minutes later you are walking out of the store with a neatly wrapped package under your arm. You are now a collector of animation art.

The problems begin when that Bugs Bunny limited edition cel has been hanging over the mantel for a couple of weeks and you begin to think that another piece of animation art would be just the thing to liven up the space between the picture window and the aspidistra. After considering this possibility for a few

days, and checking your bank account, you head back to the animation art store.

This time the situation is different. Serendipity has nothing to do with this visit. You are here for a purpose and that makes selection more complicated. There seems to be so much to chose from. That Disney setup is very appealing, but the price is a little out of your bracket and, in any case, it doesn't really go with the Bugs Bunny cel, does it? Or does that even matter? That drawing of Yosemite Sam certainly belongs with Bugs— after all, they co-starred in many movies—but it doesn't have the brightness and boldness of a cel.

The moment has arrived.

Either you forget about collecting animation art or you have to make a few decisions. Let us suppose, for a start, you determine that before your next purchase you are going to brush up on the basics (as outlined in the previous chapters) and learn something about the medium and what to look for in terms of character, complexity, and condition. Unfortunately, since public collections of animation art are few and far between, you may not have the opportunity to view first-class work first-hand, except perhaps in the gallery where you will be making your purchases. In which case, try to get hold of some auction catalogues with reproductions that will give some idea of what the originals should look like.

So you've educated yourself as far as possible, but still you have to make up your mind as to what kind of collection you hope to put together. Will it be a hodgepodge—containing animation art of different sorts from different periods and different studios—or will you specialize in some way or another?

Most serious collectors of animation art do tend to specialize, just as many collectors of paintings specialize in a given period or a given school of artists. Where animation art is concerned, a variety of ways to specialize are options. The most

obvious of these, perhaps, is to collect the work produced by a given studio, and undoubtedly there are far more collectors who concentrate on Disney than any other kind. The fact that there are so many players in this category, however, means that demand is great and prices tend to be high. This does not indicate that you should necessarily avoid Disney—there is good reason why so many people do covet Disney animation art—but it does suggest that you are likely to find greater bargains if you choose to specialize in the work of a more obscure studio.

Other collectors concentrate in terms of character (Daffy Duck, say), groups of characters (MGM animation stars), or type of character (Disney villains). Some collectors will try to find a single character in examples from different periods in which that character made different appearances. This would apply to Mickey Mouse, for example, who had many incarnations ranging from the original version, in which he was made of circles connected to rubber-hose limbs, to late versions in which he dresses like Frank Sinatra. Bugs Bunny is another character who varied a great deal over the years, and who had a different appearance in the hands of different animators (see Chapters 10 and 11). Getting to know these variations can be part of the fun of collecting. Finding good examples of the variants is part of the excitement.

Other collectors look for characters in certain situations that have significance for them. An airline pilot, for example, might collect setups that have to do with airplanes and flying. A sports fan might prefer images of characters playing tennis or football or golf.

Historically minded collectors will enjoy research as much as they enjoy acquiring the animation art itself. They may like to specialize in something like cels from the black-and-white era, or they may enjoy tracking down the work of individual artists. This is not as easy as it may seem. Although it is often

possible to use screen credits or company records to determine who was primarily responsible for the animation of a particular character, many drawings were made by assistants or in-betweeners, so that you cannot be sure you are getting work from the hand of the master. (The principal animator makes only the key drawings in a given sequence. In-betweeners fill in the stages that are needed between those drawings to ensure smooth movement. Assistants animate sequences of secondary importance.) For example, Marc Davis is justly credited as being the creator of Cruella De Vil, but not every drawing of Cruella is by Davis himself. Only experience and a good eye can lead to recognition of the real thing.

It is not surprising, perhaps, that many animation artists like to collect the work of artists who have influenced them. Andreas Deja, for instance—the brilliant animator of recent Disney villains like Scar (*The Lion King*) and Gaston (*Beauty and the Beast*)—collects drawings by animators he particularly admires, notably the late Milt Kahl, one of the premiere figures from Disney's golden age.

As noted previously, many animation professionals prefer collecting animation drawings, story sketches, and the like over collecting cels or setups because they feel that these drawings reveal far more of the talent and spirit of the artists who actually brought the characters to life. We reiterate that it is our opinion that the greatest bargains in the animation art field are to be found among these little masterpieces on paper. Certainly this is an area well worth specializing in, but at the same time it should be noted that it is an area that demands a good deal of knowledge in order to be fully enjoyed. Even some dealers are not exactly sure what they are looking at when they see a pencil drawing of a single character on a small rectangle of paper. Is it a story sketch? Is it a study for a model sheet? Is it a doodle made by an animation artist while talking on the phone? When

in doubt, dealers and auction catalogues will often describe such an item as an animation drawing, even when it is clearly *not* an animation drawing in the sense that the term would be used at the studio. There the term "animation drawing" refers only to the drawings made to be traced onto cels—or fed into the computer—by the actual character animators.

Quite a few collectors specialize in the Courvoisier setups that were produced and sold with the permission of the Disney Studio from 1938 to 1946. Others focus on the more recent Disney limited editions which have the advantage of being reasonably affordable.

Obviously cost is an important factor in building up a collection. There is little point in choosing to specialize in images from *Pinocchio* or *Fantasia* if your means are limited. On the other hand, with the same amount of capital that might buy a single classic production setup from one of these movies, you could build a first-rate collection of animation art from shows made for television.

When you have made up your mind about the direction in which you want to go, find a dealer you trust, someone who is well established and, if possible, recommended by a more seasoned collector. If Disney art is what you want to collect, the Disney organization has done a thorough job of prescreening for you, annointing a number of animation art galleries as their authorized dealers. These outlets have been thoroughly screened according to a set of stringent standards. It might be thought that the standards are too stringent—one of the leading animation dealers in the country was until recently refused recognition by Disney because his premises were not considered large enough. There are in fact a number of galleries not blessed by Disney that are not only respectable but first rate. The problem is that since this is a relatively young field the gallery situation is mercurial. An established dealership is one

that has been around just a few years, while others come and go and change hands quite quickly.

Once you feel confident enough to confide in your dealer, let him know what you are looking for and what you can afford. The fact that you cannot see what you want on the walls of his store does not mean that he doesn't have it tucked away in a print cabinet. If not, there's a good chance that he knows just where to call in order to find it for you. Also, as you become a regular buyer, he will put aside things he thinks may be of special interest to you. Never be intimidated by a dealer or by his knowledge. He *wants* to sell to *you*—that's how he earns his living—and his knowledge should be at *your* service.

A good dealer knows animation and also knows the marketplace. The prices he asks for his wares are likely to be fair, but there's no reason why you can't make an offer for a particular work that you are interested in. That does not mean the dealer has an obligation to reduce the price, but it's worth a try. The dealer selling at retail makes his profit by adding a percentage to the price he paid for a given work. In some cases a collector can avoid paying that markup by obtaining animation art from the source where the dealer obtained it in the first place, which quite often will prove to be an auction house.

This is not to say that an auction house is a wholesaler, exactly. Some of the highest prices ever paid for animation art have been bid at auction, but some of the greatest bargains in the field have also resulted from shrewd bids at auction houses.

If you have never bought at auction before, the procedure can seem intimidating, and it's probably good advice to say that you should avoid bidding at auction until your priorities as a collector have been defined and you have a basic idea of what you are looking for. Once you've reached that point, however—which will not take long—then auctions become an exciting way in which to expand your collection.

Auctioning is a form of selling that is as old as the idea of commerce. It is used to set a price for old master paintings, it is used to set a price for soy beans. There is nothing mysterious about the process. A sale of animation art is a completely unsnobbish event. If you know what you want, set yourself a sensible price limit, and keep your wits about you, it is the perfect place to hunt for superior material, and, if you're lucky, perhaps even a bargain.

The major auction houses all issue illustrated catalogues well in advance of their sales. These will give you the opportunity to see what is being offered, even if you do not have the good fortune to be in the city where the sale is being held. If you are in the area of the auction house, or have the opportunity to visit it, you can generally inspect the lots firsthand. If you have any queries about individual lots—concerning provenance, perhaps—call the auction house, ask to speak to the specialist in charge, and make sure that your questions have been answered to your satisfaction.

On the day of the auction, you can bid in person or by telephone, or you can engage a dealer to bid for you (though the dealer of course will charge a fee). All auction catalogues have detailed conditions of sale and terms of guarantee, and sometimes a useful guide for prospective buyers, delineating such practices as estimates, reserves, buyers' premiums, and, perhaps most important, how to bid. If you still have questions about the bidding process, call the auction house and ask for assistance. (At Sotheby's you should ask for the bid department.)

If this seems like a lot of trouble, it will take only a single auction to convince you that there's no more satisfying way of buying art than by going head to head with another eager collector. And if someone outbids you for that *Beany and Cecil* setup, there's always the next time.

II

THE HISTORY OF ANIMATION

5

THE PIONEER PERIOD

Although you certainly can buy a cel or animation drawing purely because of its aesthetic or nostalgic appeal, to be a serious collector it is essential to know something about the development of the art form, since such knowledge is necessary to assess the significance, and hence value, of individual works. Even more important, it enhances the collector's ability to appreciate his or her acquisitions.

One reason animation art is so satisfying to collect is that it lives up to the old adage, "Every picture tells a story." In fact, a witty storyboard sketch or a superior cel setup participates in telling more than one story. It helps describe a narrative event—the witch offers Snow White a poison apple, for example—but it also tells the initiated viewer something about the history of the medium, about the evolution of an animation studio, about the artists who

made up that studio at a given moment, about their place in the development of an art form.

Beautiful objects—whether we are talking about paintings, pieces of furniture, classic cars, or cel setups—are the products of a cultural continuum that engenders sets of rules and values. Anyone can enjoy a painting of water lilies by Claude Monet. It has an immediate impact simply as an arrangement of shapes and colors. But that enjoyment can be greatly enhanced by a knowledge of Monet's place in the history of Impressionism, and Impressionism's place in nineteenth-century art. That knowledge does not physically alter the painting, but it introduces the person who acquires the information to a world of artists and patrons, and ideas and ambitions far richer than any novel could ever be. Within the context of that world, the painting comes alive in a new and deeper way.

The fact that animation art started out as a humble form of entertainment does not mean its history is not as fascinating, in its way, as that of Impressionism. Nor does it mean that, although a collaborative effort, it was not a fruitful medium for self-expression and the exploration of ideas. Animation is an art form that was created by a group of outsiders, people who could not find a place for themselves in the conventional art world or the live-action movie studios and who managed to scrape together an existence by coaxing drawings to life on the motion picture screen. Few of the pioneers brought outstanding skills to the task, but a handful had more ability and vision than the rest. One in particular, Walt Disney, quickly outstripped all the others. But without the pioneers there could not have been a Walt Disney. They created the environment in which his genius could germinate and flourish. Inept as their films often seem, the first animators were true innovators, taking a leap into the unknown without which there would be no *Pinocchio,* no Bugs Bunny, no Roger Rabbit.

• • •

THE HISTORY OF the major studios will be treated in detail in subsequent chapters, but here we will take a brief look at early animation and its ancestors, beginning with the scientific discoveries that made animation possible. This chapter will take the story forward to the end of the silent era, which corresponds with the emergence of the Walt Disney organization as the dominant force in the industry.

Some chroniclers trace the origins of animation back to the strip-cartoonlike decoration on ancient Greek vases, or even to cave paintings. Charles Solomon, in his landmark book, *Enchanted Drawings: The History of Animation*, more plausibly dates the prehistory of animation to the seventeenth-century rise of modern science and its fascination with light and motion. In a 1645 treatise, a Jesuit scholar described the primitive form of projector known as the magic lantern and later, in a revised edition, showed how images painted on the rim of a glass disc could be used to convert the device into a story-telling tool—intended then as a teaching aid for missionaries.

Throughout the next two centuries there was much further experimentation with elaborate slide shows known as Phantasmagoria, which sometimes used rear projection and elaborate special effects. These entertainments were presented in Paris, London, and New York. Another ancestor of the animated film was the shadow puppet show, which had been popular in the Far East for a thousand years. This form of theater consisted of intricate two-dimensional figures manipulated behind a backlit screen so as to tell a story by means of moving silhouettes. It was transported to Europe in the 1770s and enjoyed a great vogue toward the end of the nineteenth century, just prior to the invention of motion pictures.

Before the movies finally arrived, all sorts of efforts were

A zoetrope is a nineteenth-century invention that provides an illusion of movement when sequences of images are viewed through slots in a spinning cylinder. Such toys are now much sought after by collectors interested in the origins of animation art.

made to create toys and optical devices to simulate natural movement, resulting in contraptions with names like the thaumatrope, phenakistoscope, stroboscope, zoetrope, praxinoscope, and the kineograph, which was in effect what we now call a flipbook. Most of these early devices involved spinning disks that could be viewed in such a way—through slits, for example—as to permit sequential hand-drawn or photographed images to appear to move. Many of these gadgets can still be acquired and offer a fascinating subfield of collecting for anyone interested in the prehistory and prototechnology of animation. Walt Disney himself was an enthusiastic collector of these primitive devices.

The first seminal figure in the history of animation per se was the British-born J. Stuart Blackton, who came to America as a child and became a vaudeville performer in his teens. Part of his act featured drawing quick cartoons on stage, but

because the images were too small for the audience to see, he hit on the idea of projecting them on a screen. He and a partner, Alfred E. Smith, produced what was probably the first stop-action animated film (in which the sequential movements of toys were photographed frame by frame, to create the illusion of life). In 1906, Blackton produced *The Humorous Phases of Funny Faces,* which is considered the first true animated film, though it shows nothing more elaborate than hand-drawn faces that change expression and vignettes such as a man raising a bowler hat.

The medium's earliest real master was Winsor McCay, one of the finest draftsmen ever to apply his imagination to the art of animation. A successful vaudeville performer and newspaper comic strip artist who had created such early masterpieces as *Dreams of the Rarebit Fiend* and the widely syndicated surrealistic *Little Nemo in Slumberland,* McCay began thinking about producing an animated version of *Little Nemo* for use in his stage act in 1910. His singular gifts as a draftsman, which emphasized accuracy, character, movement, and attitude, were especially well suited to animation. Responding to a challenge by a fellow newspaper cartoonist, McCay made four thousand drawings in India ink on translucent rice paper, the drawings held in register by a wooden frame and matched crosshairs drawn at the corners of each sheet of paper. After the drawings were photographed, McCay then tinted the black and white film, frame by frame, to match the colors in the Sunday comics. *Little Nemo,* with a live-action prologue, was premiered in April 1911 as part of McCay's vaudeville act, and was later released in movie theaters.

Since the audiences suspected that McCay's first films were tricks with live actors somehow made to look like drawings, he decided to choose for his next subject something that couldn't

be found in the contemporary world—a prehistoric animal. The result was a brilliant little movie titled *Gertie the Dinosaur* (1914), the animation of which is still astonishingly convincing today. In her time, Gertie seems to have had as powerful an impact on audiences as the special-effects dinosaurs in Steven Spielberg's *Jurassic Park* and *The Lost World* have on modern audiences.

Animation drawings and backgrounds for *Gertie* were combined on the same sheet of paper, the backgrounds traced from one image to the next. In later films, McCay introduced the idea of making animation drawings on sheets of transparent celluloid that could be photographed one by one over a single painted background, so that the background wouldn't need to be retraced for every frame of the film. He was, therefore, both animation's first master and a pioneer of the cel method, though credit for inventing the system probably belongs to an animator named Earl Hurd who patented it in 1914.

By the time *Gertie the Dinosaur* was unleashed on the public, the American animation industry was starting to take shape. The Raoul Barre studio, which opened in the Bronx in 1913, is generally acknowledged to be the first commercial production company making animated films and brought such favorite newspaper comic strips as *Mutt and Jeff*, *Happy Hooligan*, and *Hans and Fritz* to the screen.

The animation turned out by the Barre studio was extremely crude, and this is also true of the productions supervised by Barre's chief rival, John Randolph Bray. It was at the Bray studio, probably in 1917, that an animator named Bill Nolan came up with a style of drawing that became known as "rubber hose" animation. It capitalized on flexible, hose-like limbs that could bend and swing naturally, and it would be used at most studios for more than a decade. Even the early Disney cartoons

used rubber hose animation, though Disney artists like Ub Iwerks soon modified it into something less crude and more expressive.

It was only gradually that the quality of animated films began to improve, starting a slow movement toward the recognition that storytelling would one day have to take the place of strung-together gag sequences with little narrative structure. The key studios of the period were those headed by Paul Terry, Max and Dave Fleischer, Walter Lantz (in partnership with Bray), Pat Sullivan, and Walt Disney.

Terry, another ex-newspaper cartoonist, produced an extremely popular character named Farmer Al Falfa, which he later took to Paramount, where he turned out an astonishing four hundred plus Terrytoons in eight years. As can be gauged from this, he was a virtuoso of mass production, if nothing else, and it is generally acknowledged that it was at the Terry Studio that the cel system was first used to maximum effect.

One of the most ambitious animation groups in the early period was the studio run by brothers Max and Dave Fleischer. It was they who, around 1915, began to experiment with a device they called the rotoscope, which enabled an animator to trace live-action movie frames as they were projected onto a sheet of paper, creating a highly realistic illusion of movement. In collaboration with John Randolph Bray, Max Fleischer produced the first of the *Out of the Inkwell* films in which a rotoscoped clown (later known as Ko-Ko) emerged from an inkwell and embarked on a series of adventures that skillfully combined animation and live action.

In 1919, Max and Dave founded Out of the Inkwell, Inc., which later became the Fleischer Studio. Eventually, in the 1930s, they produced some extremely successful and inventive series, including those featuring Superman, Popeye, and Betty

Boop, and they even followed Disney's lead in making animated features such as *Gulliver's Travels* (see Chapter 13).

Max Fleischer's successor at the Bray studio was Walter Lantz who, in 1924, launched a combined live-action/animation series about a boy named Dinky Doodle and his dog, later replaced by another series called *Hot Dog*, starring Pete the Pup. Some of these films combined animation with live action in a somewhat novel way, but they were seldom strong from a story or gag point of view. Lantz would later earn more lasting fame as producer of the Woody Woodpecker films (see Chapter 13).

Pat Sullivan, an Australian who learned his craft as an animator at the Barre Studio, formed his own company in 1915 and the following year hired a gifted animator named Otto Messmer, the man who went on to develop the character known as Felix the Cat. The Felix cartoons were distributed by Paramount and brilliantly promoted by Sullivan (who managed to take all the credit for the cat's success). They hold up extremely well today, being skillfully drawn and often quite inventive. It is not surprising that Felix was the most popular animated character of the silent era, but as sound came in he would be surpassed in popularity by Mickey Mouse, whose creators, Walt Disney and Ub Iwerks, had come to Hollywood in 1924—a story that will be told in the next chapter.

As might be expected, animation from this period is by no means easy to find, though—given the fact that it was not taken seriously at the time—it is remarkable that any at all has come down to us. A few animation drawings have been preserved from *Gertie the Dinosaur* and some of these have been sold at major auction houses. All are in India ink on rice paper and include the traced background on the same sheet. Cels from McCay's *The Sinking of the Lusitania* have also gone under the gavel. Animation art from *Out of the Inkwell* and other pop-

ular series, such as *Felix the Cat*, has also survived. Not surprisingly, these black-and-white pieces tend to be fairly expensive and, because of the unusual techniques used, the buyer should be careful to know exactly what he is looking at.

In the case of Felix, for example, cels were employed, but in an unconventional way. The character was first drawn by the animator on a sheet of paper that was then passed to an inker so that the animator's relatively light pencil image could be translated into crisp black and white. It was this inked drawing that was sent to the camera department and shot *through* a cel on which the background had been painted—the reverse of the usual system in which the animation is on the cel and the background is on the paper underneath.

For a while, the Bray studio employed a patented system in which animation drawings were added to backgrounds that had been preprinted on sheets of paper, a technique that was soon preempted by the cel system. Crudest of all the early animation techniques was the so-called slash system used at several studios, including Barre and Fleischer. This system demanded that animation and background be drawn on separate sheets of paper. Sometimes the animation drawing was placed on top with all the surrounding white paper cut away so that the background could be seen. Sometimes the animation was placed underneath the background and a hole was "slashed" into the background so that the animation drawing showed through.

None of these early systems lasted long, but they are mentioned here because it is important to understand that the earliest animation art did not always come in the conventional cel and background format that we now take for granted. Pioneer work is rare. Most collectors will never see examples of, say, the slash system, but it would be a shame to come across drawings

of Ko-Ko the clown at a country auction and fail to bid on them because they appear to be torn—when in fact the rips in the paper are precisely what makes them valuable.

Collecting early animation art is not for the novice, unless he or she is receiving expert advice. For those who are prepared to put time and effort into studying the period, however, it is a most rewarding field.

6

THE DISNEY SHORTS

It is almost impossible to imagine what the animation industry would be like today if it had not been for the contributions of Walter Elias Disney. In its relatively short history, animation has attracted many major talents, but Disney's achievements far outshine those of any of his rivals; indeed it is conceivable that without him animation would never have emerged from the novelty phase. It was Disney's genius that gave the medium credibility.

Walt Disney was born in Chicago in 1901, the fifth of six children. He spent part of his early life on a Missouri farm and part of it in Kansas City before returning to Chicago to attend high school. Although underage, he managed to become a Red Cross ambulance driver at the end of World War I, arriving in France shortly after the Armistice had been signed. Repatriated in 1919, Disney headed back to Kansas City intent on pursuing a career as a commercial artist, having managed to acquire

some modest art training before the war despite the fact that his father had been decidedly unsympathetic to such effete activities.

Finding employment in a Kansas City advertising studio, Disney formed a friendship with a fellow employee, Ubbe (usually called Ub) Iwerks, and before long they struck out on their own, renting desk space in the offices of a publication called *Restaurant News*. But even though the two young men seem to have made a moderate success of their fledgling business, Walt soon took a more secure position—it paid all of forty dollars a week—with the Kansas City Slide Company (shortly to be renamed the Kansas City Film Ad Service) which made primitive animated commercials for the local movie theaters. Iwerks joined him there a few months later.

Kansas City Film Ad's commercials were produced primarily by means of making sequential stop-action films of jointed cardboard figures. The animation was about as crude as could be imagined, but the experience provided Disney—still in his teens—and Iwerks with a glimpse of the opportunities that might be offered by the medium. Shortly after that, Disney managed to borrow a movie camera and with it shot a reel of animated topical gags that he sold to the management of a local picture palace, the Newman Theater. Newman's Laugh-o-Grams, as they became known, were enough of a success to permit Disney to set up shop on his own under the Laugh-o-Grams name. Iwerks joined him once more, as did some other gifted young men including Hugh Harman and Rudy Ising, both of whom would play significant roles in the future of animation.

Walt Disney was nothing if not ambitious and immediately set about producing a series of contemporary versions of classic fairy tales. Of the half-dozen made, *Puss in Boots* and *The Four Musicians of Bremen* have survived, and they clearly

An extremely rare drawing for
The Sinking of the Lusitania, *1918,*
made by animation pioneer Winsor McCay.

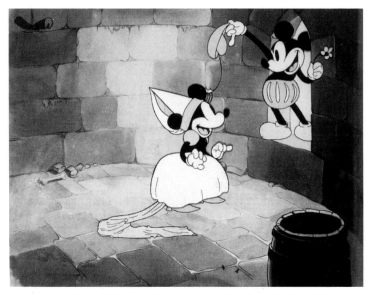

*Mickey and Minnie Mouse in a rare black-and-white cel
setup from* Ye Olden Days, *a 1933 Disney short (© Disney).*

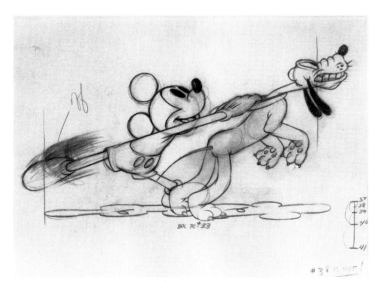

*An exceptionally lively animation drawing showing
Mickey Mouse hanging on to Pluto by his collar (© Disney).*

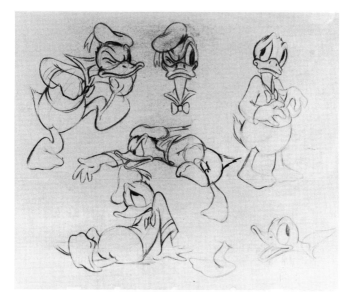

*An undated practice model sheet depicting the
many moods of Donald Duck (© Disney).*

*Color model drawing of Goofy and Donald produced for
the Disney short* Moose Hunters, *1937 (© Disney).*

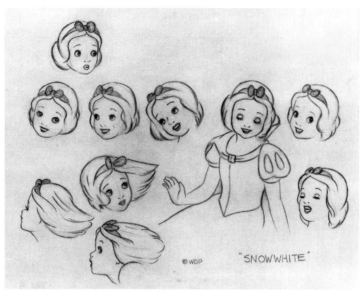

A pencil on paper practice model sheet made for Walt Disney's
Snow White and the Seven Dwarfs, *1937 (© Disney).*

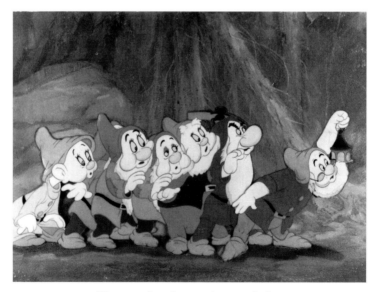

The seven dwarfs return home to find an
intruder in their cottage in this cel setup for
Snow White and the Seven Dwarfs, *1937 (© Disney).*

A production setup from the Fleischer Studio's
animated feature Gulliver's Travels, *1939.*

*Goofy is featured in this production setup from the
1940 Disney short* Tugboat Mickey *(© Disney).*

Another Tugboat Mickey *setup depicts
Donald in the engine room (© Disney).*

This setup combines a cel of Gideon, from
Pinocchio, *1940, with a wood veneer background of the*
sort often used by the Courvoisier Gallery during the period
when it was licensed to sell Disney animation art (© Disney).

A production setup from the Fleischer Studio's Superman
*cartoon series, 1941 (Superman and all related elements are trademarks
of DC Comics © 1998. All rights reserved. Used with permission).*

*Winnie the Pooh and Roo outside Piglet's house, an undated
Walt Disney Studio cel setup (© Disney; based on the Winnie
the Pooh works copyright A. A. Milne and E. H. Shephard).*

Popeye displays his prodigious strength in Rocket to Mars,
*1946, a Famous Studio short directed by noted animator
Vladimir (Bill) Tytla (© 1946 King Features Syndicate, Inc.).*

*A storyboard drawing by Bob McKimson for
Warner Bros., featuring Bugs Bunny (© Warner Bros.).*

*A handsome background layout drawing produced by the
Warner Bros. animation department (© Warner Bros.).*

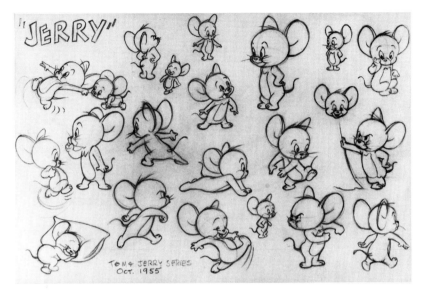

*A model sheet depicting Jerry the mouse in twenty-two poses,
MGM Studios, 1955 (™ & © Turner Entertainment Co.).*

*This cel (c. 1958) shows Ruff and Reddy, the stars of Hanna-
Barbera's first television cartoon show (™ & © Hanna-Barbera).*

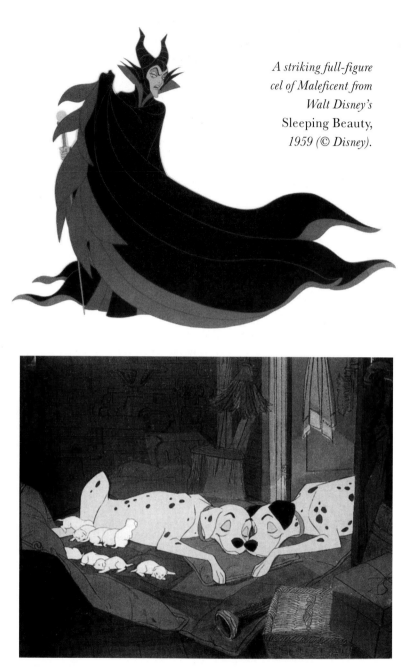

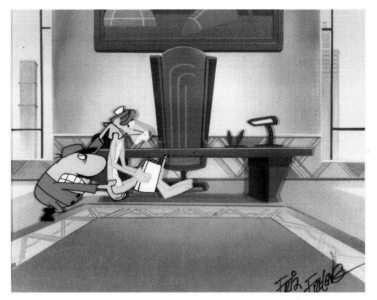

This cel of the Pink Panther and the Inspector has been applied to a non-matching production background from the DePatie-Freleng television series (courtesy of David H. DePatie).

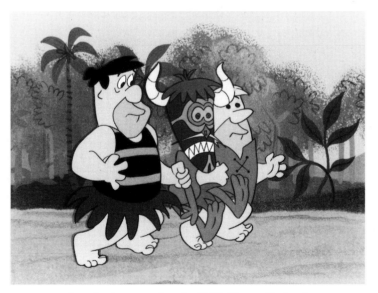

A production setup from (c. 1965) Hanna-Barbera's The Flintstones *(™ & © Hanna-Barbera).*

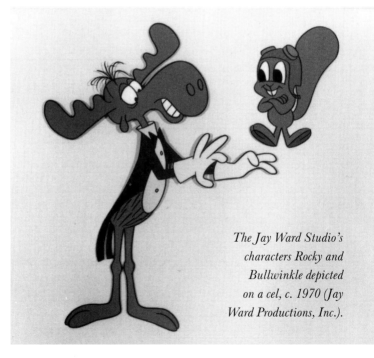

A 1966 cel from the MGM–Chuck Jones television perennial, How the Grinch Stole Christmas *(™ & © Turner Entertainment Co. and Dr. Suess Enterprise).*

The Jay Ward Studio's characters Rocky and Bullwinkle depicted on a cel, c. 1970 (Jay Ward Productions, Inc.).

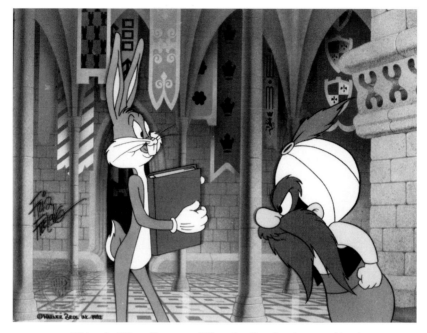

*This cel of Bugs Bunny and Yosemite Sam has been combined
with a printed background and is signed by the Warner Bros.
director Friz Freleng, 1982 (© Warner Bros.).*

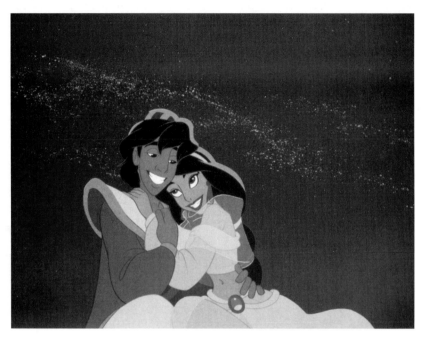

Aladdin and Princess Jasmine are seen at the climax of Disney's Aladdin, *1992. Both are seen full face and smiling, making this a desirable setup (© Disney).*

demonstrate that this untried team of midwesterners was capable of competing with the most experienced and able of their New York contemporaries. Disney's story sense is already in evidence in *Puss in Boots,* as is Iwerks's animation skill, which would have made him an instant star at any of the studios of the period.

Good as they were, these fairy tales did not prove to be a commercial success, and the Laugh-o-Grams group had to scramble to pay the bills. One project that Disney managed to rustle up money for was a film on dental hygiene underwritten by a local dentist. In this proto-infomercial, animation was combined with live action, a notion that was probably inspired by Fleischer's *Out of the Inkwell* shorts. In 1923, Disney decided to launch a new series of films based on that same principle. The theme of the series would be the adventures of an updated version of Lewis Carroll's Alice character.

To play the heroine, Disney hired a little girl named Virginia Davis, who came complete with Mary Pickford ringlets. In making *Alice's Wonderland,* the young actress was filmed in front of a white screen, interacting with characters she could only imagine. Later this footage was combined in the printing process with animation planned to match her movements but shot on a second strip of film. The technique worked well from the first, but by the time this pilot film was completed Disney had run out of capital and was forced to close his Kansas City studio.

Disney was disappointed but not deterred. He still saw himself as having a future in the motion picture industry and in the summer of 1923, aged twenty-one, he headed for Hollywood. His older brother Roy was already there, recuperating from tuberculosis, and the two joined forces to launch a new animation business. Using *Alice's Wonderland* as his sample, Walt was able to obtain a distribution deal and the series was finally

launched with Virginia Davis moving to California to reprise her role. (She was later succeeded by actresses Dawn O'Day and Margie Gay.) Between 1923 and 1927, more than sixty *Alice* Comedies were produced. During the course of this run, Disney brought out several of his Kansas City associates, most notably Ub Iwerks who for a while was in partnership with Walt and Roy, owning 20 percent of the studio.

In 1927, Disney replaced the *Alice* Comedies with a new all-animated series featuring Oswald the Lucky Rabbit. Designed by Iwerks, presumably with considerable input from Disney, Oswald was a state-of-the-art character, more compact than the typical "rubber-hose" figures emanating from the other studios, and capable of more naturalistic movement. Disney, whose strong story sense was already in evidence, placed Oswald in situations that would spotlight his mischievous persona to strong effect. In particular, Disney demanded a flow in the way in which gags were presented, so that one seemed to grow out of another. In cartoons from other studios, the sequence of gags tended to be arbitrary, they did not add up to anything. Disney understood from the first that, however important the parts, the impact on the audience of the whole was what really counted.

Oswald was the immediate precursor of Mickey Mouse—in both spirit and appearance—and within a surprisingly short time he became a favorite of movie audiences. The first collectible Disney animation art comes from these early Oswald cartoons, a few surviving animation drawings having found their way onto the market. These have great rarity value and are important both as documents of the history of early animation in general and of Disney animation in particular.

The Oswald cartoons were distributed by Charles Mintz—who had demanded and gotten the copyright to the character—and when his contract with Mintz came up for renewal in

1928, Disney was shocked to discover that Mintz was prepared to snatch Oswald away from him unless Disney agreed to produce the films for less money. When Disney refused, he found that Mintz had arranged for several veteran Disney artists to take over the series, which soon passed into the hands of Walter Lantz where Oswald—now in the sound era—became a conventionally cocky cartoon character who enjoyed modest success before disappearing during World War II. Post-Disney examples of Oswald animation art are also fairly rare, though considerably less valuable than comparable examples from the Disney period.

When Mintz made his raid on the Disney talent pool, Iwerks was the only major animator left at the studio. Disney, fighting for his professional life, quickly came up with the concept for a new character that he handed over to Iwerks to design. The result was Mickey Mouse (who narrowly escaped being called Mortimer), soon to be known around the world, from Valparaiso to Vladivostok.

The first Mickey short was *Plane Crazy*, but before it was released it had become evident that the age of talking pictures was at hand, thanks to the success of Al Jolson in *The Jazz Singer*. Disney realized that effectively combining animation with sound would be crucial to the success of his new character. Instead of just adding sound to *Plane Crazy*, however, Disney planned a new cartoon that would be designed to take full advantage of sound—animated in such a way that the movements of the characters were synchronized with the beat of the music scored to accompany the film.

First shown at New York's Colony Theater on November 18, 1928, *Steamboat Willie*, as the film came to be called, was a genuine overnight success. Audiences could not get enough of the cheeky rodent in short pants who was capable of squeezing calliope music out of farmyard animals. When soundtracks were

added to *Plane Crazy* and *Gallopin' Gaucho*—which also had been planned as silents—it was discovered that Mickey could be as brave as Lindbergh and as dashing as Valentino.

Artwork from these pioneering Mickey Mouse shorts is extremely desirable. Disney, who claimed to be unsentimental about past triumphs, kept examples in his office throughout his life. A production setup from *Plane Crazy*—cel plus watercolor background—was sold at auction in 1991 for $44,000. More common, but still rare, are animation drawings from *Steamboat Willie* and *Plane Crazy,* some examples identifiable as being by Ub Iwerks.

It was an aspect of Iwerks's genius that he had designed Mickey in such a way—as an assemblage of circles articulated by a modified version of those ubiquitous rubber-hose limbs—that he was easy to animate yet capable of a considerable expressive range. This is evident in the animation drawings from the late 1920s and early 1930s that are now in private hands. These appear on the market from time to time and are numerous enough to be reasonably affordable. Indeed, a good drawing from a classic early Mickey short such as *The Jazz Fool* or *Barnyard Olympics,* rich in historical resonance, is apt to be far less expensive than a mediocre cel setup from a recent Disney feature.

If Iwerks was responsible for Mickey's appearance, however, it was Disney who provided Mickey's voice and supervised the creation of the situations and stories that allowed Mickey to evolve into a universal character. So quickly did that character become established that before the end of 1929, Disney had acquired the reputation and means to launch a new series of shorts that he would call the Silly Symphonies.

The Silly Symphonies came about in part because Disney was ready to expand his range and in part because his first

musical director, Carl Stalling—another Kansas City veteran—was such a resolute proponent of music's role in animation. Disney was fully aware of music's importance but felt that action must come first, certainly in the Mickey Mouse shorts. But Stalling was one of the few people at the studio capable of standing up to Disney, and their many arguments helped propagate the idea of a series of comedy shorts in which music would be the driving force.

The first of the Silly Symphonies was *The Skeleton Dance,* for which brilliant animation by Ub Iwerks was matched with a clever score by Stalling as audiences were presented with the spectacle of skeletons coming to life in a spooky graveyard. Like *Steamboat Willie, The Skeleton Dance* was an immediate hit, playing for weeks in New York at a time when the cartoons on a movie theater program generally changed every few days.

The series had hardly been launched, however, when both Iwerks and Stalling quit. (As will be seen in Chapter 13, Iwerks set up his own studio. Stalling joined him for a while and eventually became the musical director for the Warner Bros. animation department.) By this point Disney was well on his way toward building a team of talented artists, capable of taking over both the Mickey Mouse shorts and the Symphonies.

Animation art, especially production setups, from the early Symphonies is relatively rare. It should be noted that, prior to 1932, all Disney cartoons were made in black and white, so it follows that cels and layouts are in black and white as well. (Layouts and storyboard drawings often feature colored pencil work, but this was used essentially to help articulate the drawing, by emphasizing different elements). In 1932, the studio obtained exclusive rights to use Technicolor's new three-strip color system for animation for the next three years. From that time on—starting with *Flowers and Trees*—all Silly Symphonies

were made in color. The Mickey Mouse shorts continued to be made in black and white until 1935.

Naturally, the shift to color is a crucial change from a collectible point of view. From a strictly historical perspective, the much rarer black-and-white cels and backgrounds are priceless. Colored cels and backgrounds, on the other hand, are often more obviously attractive, especially since the Disney artists' skills improved with time. Production setups from a number of the early Silly Symphonies have appeared on the market in recent years. Among titles that have been represented by good examples are *Lullaby Land, The Grasshopper and the Ants, The Night Before Christmas,* and the most famous Symphony of all, *The Three Little Pigs,* which took the nation by storm in 1933. Setups from these productions have attracted high prices, some in the tens of thousands of dollars. (It should be noted too that some cels from early classics like *The Three Little Pigs* were retroactively matched with Corvoisier backgrounds several years later.)

The first Mickey cartoon to be made in color was *The Band Concert,* a 1935 miniature masterpiece co-starring Donald Duck, who had made his cackling debut in the 1934 short, *The Wise Little Hen.*

By 1935, several of the so-called standard characters— Mickey, Minnie, Pluto, Goofy (originally called Dippy Dawg), and Donald—had evolved into well-defined personalities. Mickey, whose behavior verged on the sadistic in some early cartoons, had now been modified into a michievous but basically good-hearted character, largely because of pressure from parental groups who thought the mouse was in danger of exerting a bad influence on children. His age was indeterminate—sometimes he was a boy, sometimes a young adult—though this tends to derive more from situation than

appearance and is not always apparent from individual cels or animation drawings.

Animators loved to work with Mickey, and it would be impossible to list all the artists who contributed to his development. Most of the rising stars at the studio drew him from time to time, but it is worth singling out story artist Ted Sears and animator Fred Moore as being among the outstanding Mickey Mouse virtuosi; in fact, they were called upon to put together a book on drawing Mickey for the edification of staff newcomers. It is seldom possible to identify the creator of a specific animation drawing with complete certainty (it may have been by an assistant or an in-betweener), but several drawings of Mickey identified as being by Fred Moore have been offered at auction and these have added value for knowledgeable collectors.

Donald Duck's character coalesced around the voice talent of Clarence "Ducky" Nash, who provided the perfect angry squawk for the irascible bird. First drawn by Art Babbitt and Dick Huemer, the duck began life with a long bill but his appearance changed quickly to the one with which we are familiar today. The mature Donald—if such a word can be used to describe him—owed a great deal to the contributions of animators Dick Lundy and Fred Spencer. By 1935 Donald was a key member of the Disney repertory company, his rage and paranoia—many animators considered Donald assignments as a form of punishment—providing a fine foil for the increasingly well-adjusted Mickey. The best cels and drawings of Donald are those that capture, in a single image, the volatility of his character. In a typical instance, he is captured on the edge of rage, his beak twisted into a mask of frustration, a fist shaking at the universe.

In 1930, in a cartoon titled *The Chain Gang,* Mickey was pursued by a pair of bloodhounds. Later that same year, in *The*

Picnic, one of these bloodhounds metamorphosed into Minnie's pet dog, Rover. In *The Moose Hunt,* the following year, Rover became Mickey's pet, now renamed Pluto. For several years, though, Pluto continued to remain a secondary character, useful primarily as a means of setting up situations for Mickey. Finally, in 1934, he came fully into his own in a short named *Playful Pluto,* which featured a gag devised by story artist Webb Smith, in which the accident-prone pup became entangled with a strip of sticky flypaper. That gag helped crystalize the character of Pluto, which was further refined by a number of animators, most notably Norm Ferguson.

If Pluto began as a supporting character, Goofy was little more than a bit player—from 1932, when he made his brief debut in *Mickey's Revue,* until 1935, when he began to emerge from obscurity in *Mickey's Service Station.* The animator most responsible for Goofy's emergence was Art Babbitt, who felt that the Goof had great potential if only his personality could be more clearly delineated. With Disney's encouragement, Babbitt developed a short gag from *Mickey's Service Station* into a protracted sequence that demonstrated what Goofy was capable of. Babbitt continued his elaboration of Goofy's character in *Moving Day* (1935), working closely with Pinto Colvig, the story man who supplied the character's voice. After that, Goofy's stardom was assured, his temperament that of a befuddled optimist—"a good-natured hick" to borrow Babbitt's words—whose thought processes are so close to the surface that they are evident in his facial expressions and body language. Especially striking are those cels and drawings in which his confusion is captured graphically, his eyes hopeful yet wary, his pose awkward yet alert. Good-quality Goofy art of any period is highly valued, but examples from the late 1930s are especially desirable.

It should not be forgotten, either, that many other characters—from Pegleg Pete to Horace Horsecollar to Clarabelle Cow to Clara Cluck—appeared in the early Mickey shorts and all are of considerable interest to the informed collector. They differ from the key standard characters, however, in that none of them achieved any richness of personality. (Most Disney fans know what Horace looks like, but few can point to a key scene involving this character.) This makes them less desirable to most collectors, but the fact that they represent an important period of Disney animation makes them interesting to anyone with a strong interest in the history of the medium.

From a quality point of view, the peak period for both the Silly Symphonies and the standard character shorts was the mid-1930s, and many superb examples of animation art from this period are now in circulation. Starting in 1934, however, the studio began gearing up for a new challenge: Disney had decided he was going to produce a feature-length animated film. The shorts would not be abandoned, but many things needed to be rethought, as we will discuss in the next chapter. The project had little effect on the cartoons featuring Mickey, Donald, Goofy, and Pluto, but it transformed the Silly Symphony series into something like a laboratory for the problems that would be encountered in animating *Snow White and the Seven Dwarfs*.

Snow White would demand a high level of character animation and Disney, always a perfectionist, began to require more of the animators working on new Silly Symphonies. Often he was extremely critical, as is evident from surviving transcripts of story meetings and post-screening sessions, at other times he was more than satisfied with the way a character was presented, as in the case of Jenny Wren in the delightful 1935 short *Who Killed Cock Robin*. Jenny is a feathered caricature of Mae

West, similar to takeoffs of other stars like W. C. Fields, Charlie Chaplin, Laurel and Hardy, Groucho Marx, and Katherine Hepburn that appear is several other Symphonies such as *Broken Toys, Mickey's Premiere,* and *Mother Goose Goes Hollywood.* The celebrity caricatures make another fascinating subcategory of collectible.

Caricatures like these helped prepare Disney artists for the difficult task of animating human characters such as Snow White, the Wicked Queen, and the Huntsman. Naturalistic humans are especially difficult to animate because the audience knows how they are supposed to move (as opposed to a mouse in short pants or a duck in a sailor suit, creatures that few of us have seen in real life). Early efforts, like the awkwardly drawn 1934 Silly Symphony *The Goddess of Spring,* show how far the Disney animators still had to go. The art training that became part of the studio routine (see Chapter 7) helped them overcome their lack of proficiency with the human figure, and rapid improvement in this area is very evident in cels and animation drawings from the 1935–1937 period.

There were purely technical changes as well, which the serious collector should understand. Until *Snow White* went into full production, all Disney animation was done on standard-size animation paper (9½" by 12"), which is known as "five field," a camera term describing the maximum size of image that can be accommodated by that sheet of paper, and by the matching cel. *Snow White* would require scenes in which there were many characters on screen at once. On the old standard-size paper, some of these characters—the animals helping Snow White, for example—would have to be drawn to a minute scale, making the animator's job difficult. To overcome this problem, Disney had the entire studio refitted to accommodate the use of larger size paper and cels. (This meant that

animation tables had to be modified as well, since the pegs that hold animation paper and cels in register had to be positioned differently.) Soon the new size of paper—six and a half field rather than five field—was being used for shorts, too, and these films benefited greatly from the increased detail that was now possible. This is especially evident in some of the later Silly Symphonies, such as *Woodland Cafe, The Old Mill,* and *Wynken, Blynken and Nod.*

The last of the seventy-five Silly Symphonies, a remake of *The Ugly Duckling,* was produced in 1939. *Ferdinand the Bull,* released in 1938, was the first of a new untitled series of special shorts that over the years would include such well-known titles as *Chicken Little* (1943), *The Brave Engineer* (1950), *Morris the Midget Moose* (1950), *Lambert the Sheepish Lion* (1950), *Susie the Little Blue Coupe* (1952), and *The Martins and the Coys* (1954). Animation art from some of these shorts has made its way onto the market. Courvoisier, for example, offered a number of cel setups from *Ferdinand the Bull,* featuring a variety of backgrounds. More unusual are the title cards from *Lambert the Sheepish Lion* and *Susie the Little Blue Coupe* that have appeared at auction in recent years. Each features a stylized watercolor background, the *Lambert* example foreshadowing *The Lion King* in its depiction of the king of beasts silhouetted against a starry sky.

Still more stylized was the graphically inventive *Toot, Whistle, Plunk, and Boom* (1953), the first Cinemascope cartoon, which combined a fifties design look with the need to adapt animation to the letterbox screen format. Another innovative short was *Adventures in Music: Melody* (also 1953), an experiment in 3-D animation.

From the late thirties on, the Disney studio was primarily focused on the production of feature films, with most of the key animation talent being employed in this capacity, though

even the top artists would be released from time to time—as a kind of working vacation—to contribute to a Mickey short or a special. For the most part, though, the standard character cartoons were handed over to units that specialized in dealing with Mickey, Donald, Pluto, and Goofy as well as newer characters like Chip 'n' Dale.

Chip 'n' Dale are among several major characters spun off from Donald Duck cartoons. (Others include Daisy Duck and Donald's nephews, Huey, Dewey, and Louie.) This is hardly surprising since by the late thirties Donald had definitively taken over from Mickey as Disney's most popular character. Although difficult to animate, he was easy to devise situations for, and this resulted in his becoming the star of 128 shorts between 1936 and 1961, eight more than Mickey. (This does not include Mouse shorts in which Donald was merely the co-star.) For obvious reasons, good animation art featuring the choleric duck is not uncommon, though exceptional examples still command high prices.

Goofy also grew more popular as time went by, reaching his peak in the 1940s and 1950s. The first short to bear his name on the title card was released in 1939, and the last—number 48—in 1965, though he has in recent years enjoyed a revival as the star of two feature films. Perhaps the most collectible of Goofy items are those in which he demonstrates how *not* to master some task such as bringing up children (*Fathers Are People*), becoming a defensive driver (*Motor Mania*), or playing basketball (*Double Dribble*).

For most people, collecting animation art is about choosing individual images rather than examples from outstanding movies. A great cel of Mickey from a forgotten cartoon may be more desirable than a less interesting cel from a masterpiece like *The Brave Little Tailor*. Still, it cannot be emphasized too strongly that a knowledge of the movies themselves can greatly

enhance the enjoyment of any collection. It is fascinating, for example, to observe how Mickey evolves over the years, becoming more flexible and expressive, going from the primitive but archetypal character in short red pants to the dapper young man about town of the fifties who dressed like Frank Sinatra on a trip to Hawaii.

The same thing applies to the other stock characters. Studying the movies across the years by means of the animation art that went into them, we see how Donald, Goofy, and the rest developed indelible personalities that would ensure their survival in our collective imagination decades after the cartoons that featured them stopped being produced on a regular basis.

As we mentioned earlier, as recently as the late seventies, people were surprised that anyone would be prepared to pay significant sums for "cartoon" art of any kind. Now all that has changed and it is not uncommon for outstanding production setups to sell for tens of thousands of dollars, making newspaper headlines; yet it is still possible to find lively storyboard sketches and animation drawings for a couple of hundred dollars apiece.

Sometimes the storyboard sketches that are offered represent scenes that have not appeared in any movie, but that does not make them any the less genuine. It is the nature of the storyboard to remain in a state of flux until production begins. Consisting of drawings pinned in sequence to a corkboard, its images—often surprisingly detailed—are used to tell the story of the cartoon *before* the animation process begins.

This system was developed at the Disney studio. If a gag was replaced in the story, or modified—and this happened all the time—then a set of sketches, perhaps six or ten, might be taken down and put aside. Often, it can be assumed, a story man would take some of these discarded sketches home or

trade them with another artist, and thus, many years later, they might eventually find their way onto the market. Even the discarded sketches are genuine Disney animation art, and their quality can be as high as that of any of the sketches that remained on the storyboard.

Storyboard sketches are usually numbered by hand, showing where they fit into the story sequence. Some are quite elaborate and indicate camera moves and changes in field size.

Although occasionally initiated by the storyboard artists, this mapping of camera movements eventually became the responsibility of the layout artists who function as art directors, directors of photography, and film editors rolled into one. It is the layout artist's job to design the background of a scene (as well as some foreground elements), to show how a character moves through that scene, and to indicate how the camera must move in response to the action. Layout drawings for Disney shorts of the thirties and forties—produced by artists like Hugh Hennesy and Charles Philippi—are often magnificent examples of draftsmanship, of special note to anyone with an interest in the technical aspects of animation but accessible to those who appreciate skill with a pencil.

As noted in Chapter 2, backgrounds were painted exactly from these layout drawings. Invention was forbidden to the background artist—his job was to accommodate the characters' movements as defined by the layout man—but the skill displayed in rendering form and detail makes background art immensely attractive collectibles. Of special note are the early black-and-white backgrounds, many painted by Emil Flohri, who for some time was Disney's only background artist.

In the case of animation drawings, nothing captures the spirit of early Disney films more than the simple pencil sketches in which such artists as Norm Ferguson, Les Clark,

Ham Luske, Bill Tytla, and scores of others were able to breathe life into the characters, making Mickey and Donald and the rest seem as real as your next-door neighbors.

Without those drawings, there would be nothing. They are where the magic resides. It is through them—to borrow a phrase from two of the studio's greatest animators, Frank Thomas and Ollie Johnston—that Disney was able to sustain "the illusion of life."

7

THE FIRST DISNEY FEATURES

Walt Disney's decision to expand into feature-length animated films was prompted partly by ambition and partly by economics. The Disney shorts were enormously popular, but the revenues they produced were limited, since the rentals paid by theaters were based on the length of the film being screened. An 80-minute feature film would earn ten times as much as the 8-minute Mickey Mouse cartoon that preceded it, even though the cartoon may have received equal billing on the theater marquee, as was often the case.

Even without the financial incentive, however, it is tempting to think that Disney wanted to make feature-length animated films because he had a vision for the medium, one that few others shared at the time, and an ambition to take it to its logical conclusion. The orthodox wisdom of the period was that it was one thing to keep an audience laughing at animated antics for a few minutes at a stretch, but you couldn't expect anyone to

pay to watch an hour or more of that kind of thing. What the industry pundits failed to realize was that Disney did not intend to subject audiences to 80 minutes of gag routines. There would be plenty of comic relief, certainly, but his aim was to tell a kind of story that had not been attempted in animated form before—a narrative that dealt with such emotions as vanity, and jealousy, and pathos, and betrayed innocence in as much depth as any live-action movie. To make his intentions more accessible to audiences, he decided that the studio's first effort should be based on a story that was universally familiar—a classic fairy tale—so that the focus would be on the skill of the telling rather than on the novelty of the story told.

No one is quite sure when Disney began to think about making an animated feature. It is known, however, that the inspiration for his choice of *Snow White and the Seven Dwarfs* as its subject can be traced back at least to 1917, when as a teenager in Kansas City, he attended a screening of a live-action silent version of *Snow White* starring Marguerite Clark, an experience that was a seminal event in his early life.

By the summer of 1934, Disney's notions about *Snow White*—which at first was referred to as "the Feature Symphony"—had begun to take shape. A tentative outline was circulated at the studio and requests were made for suggestions pertaining to gags and situations. A great deal of attention was paid to the appearance and personalities of the dwarfs, who in traditional versions of the story are virtually anonymous. From this we can see that Disney understood that in a feature-length film every character, however minor, would have to be carefully conceived and differentiated from all the others. This can be seen clearly in the animation art that has come down to us. Even the animals in *Snow White*—every rabbit, squirrel, and sparrow—seem to have a distinct personality.

The skill that would produce this kind of character differentiation was not immediately available in 1934. As noted in the last chapter, a training program had been set up so that Disney artists could receive instruction in subjects like life drawing, but as the pre-production of *Snow White* got under way a full-fledged art school was established at the studio under the direction of Don Graham, previously an instructor at Chouinard Art School. He also traveled around the country recruiting the talent that would be needed to create the film.

In 1934 and well into 1935 the emphasis was on story and basic visualization of the characters and settings. A key contributor to this aspect of the project was the Swiss-born artist Albert Hurter, who had joined the studio in 1932 and whose position there was unique. Hurter was neither an animator nor a story artist. He was, in fact, what would become known later as an inspirational artist. His job was to doodle interesting characters and milieus that might spark the imaginations of other Disney artists. At times he was permitted to invent freely, without reference to any specific project, which did indeed generate many ideas for Silly Symphonies. With the advent of *Snow White*, however, he was set to drawing dwarfs and rendering rustic furnishings and the gnarled roots of ancient trees. Hurter had a whimsical, middle-European sensibility that was perfectly suited to the requirements of presenting fairy tale material. His influence on the character design and art direction of *Snow White* was incalculable, and any collector who comes into possession of a drawing by Albert Hurter—from whatever period—can consider himself very fortunate.

Among the men and women who built on Hurter's work were art directors and layout artists including Charles Philippi, Hugh Hennesy, Terrell Stapp, McLaren Stewart, Harold Miles, Tom Codrick, Gustav Tenggren, Ken Anderson, and Ken

O'Connor. Background artists who translated layouts into full-color paintings were Samuel Armstrong, Mique Nelson, Merele Cox, Claude Coats, Phil Dike, Ray Lockrem, and Maurice Noble.

(Names are included here and elsewhere because signed artwork appears on the market from time to time and a signature can help establish authenticity. It is impossible to include the names of everyone involved in the making of a given film, but if a signature is found on what appears to be an image from, say, *Snow White*, the collector should check to see if that name appears in the credits.)

In terms of character design, Hurter's chief associate was Joe Grant, who became head of the character model department, and who, at the time of this writing, is the only member of the *Snow White* team still employed at the studio, where he remains an active member of the feature animation story group. Through their drawings and model sheets—examples of which are in circulation—Hurter and Grant created the "bible" that formed the essential guide for the animators.

Among the key animators involved with *Snow White* were Ham Luske (Snow White), Fred Moore, Bill Tytla, Fred Spencer, and Frank Thomas (Dwarfs), Art Babbitt (the Queen), Norm Ferguson (the Queen as witch), and Milt Kahl, Eric Larson, and Jim Algar (animals). Anyone desiring a souvenir of Disney's first feature would be well advised to consider buying an animation drawing from the production. Fine examples identified as having been made by major animators like Tytla and Natwick have sold, in the 1990s, in the range of $750–$1,000, while some anonymous drawings have gone for as little as $275.

At the other end of the scale, good quality cel setups from *Snow White* with production backgrounds often sell for tens of

thousands of dollars, and at least one changed hands for more than $200,000. Collectors of cels should consider the fairly numerous Courvoisier setups marketed soon after *Snow White*'s release. As discussed in Chapter 1, these consist of genuine production cels matched with specially devised backgrounds. A few of them have topped $10,000, but many are available for considerably less, some simple examples selling for not much more than the price of a top-quality animation drawing.

Courvoisier setups can be identified by the labels and embossed logos. Production setups and animation art of all kinds from the Disney studio often bear studio stamps and other identifying information such as production notes. The absence of such stamps and notes does not, however, mean that a given drawing or setup is not genuine. It indicates, rather, that there were many routes by which animation material found its way out of the studio, not all of them controlled or sanctioned by management.

The success of *Snow White* permitted Disney to build a new studio—a full-scale motion picture lot with a campus-like atmosphere—on the property that still houses the company's headquarters in Burbank. Disney also began to plan a whole series of animated feature films. The next to go into production was *Pinocchio*, which some critics have described as the finest animated film ever made. Undoubtedly it is one of the best, and this is reflected in the quality of animation art from the movie that has appeared on the market. Interestingly enough, the production got off to a bad start. Perhaps feeling overconfident because of the success of his first feature, Walt Disney plunged into *Pinocchio* without solving all of the problems inherent in bringing the story to the screen, and after six months he had to call a temporary halt. One of the problems

was the personality of Jiminy Cricket. Although physically small, and thus difficult to animate when sharing the screen with full-size characters, he had to seem larger than life—a tough challenge but one that was eventually met by animators such as Ward Kimball, Wolfgang Reitherman, and Don Towsley.

Even more daunting were the difficulties encountered in bringing Pinocchio to life. Should he be animated as a puppet or as a young boy? At first the puppet solution was tried, but although the character was assigned to top animators including Milt Kahl, Frank Thomas, and Ollie Johnston, the results were disappointing. Finally it was decided to animate Pinocchio as a slightly stiff-limbed boy in all but the few scenes where he appears on strings. Tests showed that this worked much better and the production was able to go forward.

In addition to these technical problems, it took all of Walt Disney's great storytelling skill to adapt Carlo Collodi's book for the screen. Disney has often been criticized for producing a film calculated to scare children. The fact is, while the movie does contain frightening scenes, it is far less horrific than the original. Disney succeeded in toning down the book's terror while retaining just enough scary elements to give the story an edge, without which it would not seem nearly as powerful.

Pinocchio does not shy away from representing evil. This is especially evident in the film's portrayal of the sadistic puppet master Stromboli. Animated principally by Bill Tytla, Stromboli is one of the greatest of Disney villains—and certainly the most physically menacing—which is conveyed most convincingly by animation drawings in which his beard bristles, his eyes roll fiercely, his bulging belly threatens to throw him off-kilter, and his arms are thrown out to restore his balance. Expressive gesture of this kind, whether rendered in pencil or pen and paint,

provides the basis for memorable animation art. Not surprisingly, drawings and cels representing Stromboli are highly valued by collectors.

Pinocchio was marked by superb art direction, arguably the best ever, but very few of the magnificent layout drawings made for this production have made their way onto the market. Any that do should be highly prized. Backgrounds are more commonplace, both as part of cel setups and as separate entities, and many of these are extremely fine, including several identified as being the work of Claude Coats, then head of the background department.

In their indispensible book, *Disney Animation: The Illusion of Life*, Frank Thomas and Ollie Johnston point to Geppetto's pet kitten Figaro, animated principally by Eric Larson, as representing a key advance in the evolution of animation at the studio—"one of the finest examples of pure pantomime ever done"—and this is apparent from the evidence of storyboard sketches, animation drawings, and cels. Figaro is especially well represented in terms of Courvoisier setups, a fact that demonstrates how the character's popularity was out of all proportion to his importance to the story. (It resulted in Figaro's appearance in half a dozen cartoon shorts between 1943 and 1949.)

It goes without saying that the most desirable character from the classic movie is Pinocchio himself—"Pinoke" as he was referred to by the studio artists—and indeed he is as engaging in cels and drawings as he is on screen, his personality coming across as effectively in still images as in moving ones. Jiminy Cricket is also much sought after in collectible form, and he too makes a strong impression in static images. Other characters of note for collectors include Stromboli and his co-villains J. Worthington Foulfellow—otherwise known as "Honest

John"—and Gideon, the silk-tongued fox and half-witted cat duo who persuade Pinoke that stardom on the puppet stage and the hedonism of Pleasure Island are preferable to schoolbooks and hard work.

Just ten months after *Pinocchio* came *Fantasia,* released in November of 1940. This feature was the result of a casual meeting between Walt Disney and the noted symphony conductor Leopold Stokowski, who had expressed a desire to work with the studio. The initial consequence of this was that Stokowski offered to conduct the score of Paul Dukas's *The Sorcerer's Apprentice,* a film version of which was planned as a showcase for Mickey Mouse. Put into production in 1937, it was intended as a two-reel short, but Stokowski suggested that there might be some point to assembling a series of shorts, each animated to a piece of classical music, in a full-length feature. Disney responded enthusiastically to the idea, and critic and musicologist Deems Taylor was brought in to work with studio artists on planning the components of the movie.

After many pieces of music were considered—from Wagner's *Ride of the Valkyries* to Debussy's *Clair de Lune*—eight were finally chosen, each providing the basis for a segment of what was, in fact, an anthology film rather than a feature in the conventional sense. The first segment uses Bach's *Toccata and Fugue in D Minor* and employs largely abstract imagery aimed at achieving an effect that Walt Disney described as sitting in the audience at a symphony concert with one's eyes half closed, permitting sounds to be manifested in terms of shapes and colors. The material was animated primarily by artists from the effects department. Very little of this work has appeared on the market. Concept watercolors relating to this segment, showing Stokowski and the orchestra in simplified silhouette, are among the rarities from this production that

have surfaced at auction. The abstract images seen on screen were influenced by the work of the German animator Oskar Fischinger, who consulted on the project. Perhaps because they do not show familiar characters, they are not valued especially highly.

The next segment is based on Tchaikowsky's *Nutcracker Suite* and collectors have had access to far more imagery from this section, which is very popular. This segment is divided into short parts, every one of which is a severely edited version of one of the dances that make up Tchaikowsky's suite. Taken together, they add up to the cycle of the seasons, each tableau being assigned to a different set of characters. "The Dance of the Sugar Plum Fairy," for instance, is enacted by the slender Dewdrop Fairies who bring blossoms to variegated life with their delicate touch. Later they find their seasonal counterparts in the Autumn Fairies, Frost Fairies, and Snowflake Fairies, but there are many other characters as well, including the Thistle Boys and the Orchid Girls.

Most delightful of all are the Mushroom Dancers who perform to Tchaikowsky's "Chinese Dance." Animated principally by Art Babbitt, the Mushroom Dancers—and especially Hop Low, the awkward baby of the troupe—are among the most successful characters in *Fantasia* because the mushroom shape is inherently well suited to animation design, and because they are brought to life with a blend of grace and humor. They are especially well represented in the form of Courvoisier setups, though production setups, cels, animation drawings, layouts, and concept pastels have also appeared on the market.

The third segment—to many the highlight of the entire movie—is *The Sorcerer's Apprentice,* in which Mickey Mouse is cast as an Everyman who becomes carried away by supernatural powers he "borrows" from the mighty wizard to whom he

is apprenticed. From the outset, Walt Disney seems to have conceived of this as one of Mickey's classic performances and attached his top Mouse specialists to the task of propelling the original Disney superstar to new heights. Fred Moore was placed in charge of devising a version of Mickey that would be shorter and cuter, yet more expressive and capable of embodying a wider range of emotions. (Among other things, he was given eyes with pupils that could register more subtle responses than his old button eyes.) Other veteran Mickey artists like Les Clark were also called upon, as were younger artists such as Preston Blair, who did much to set the standards of animation for the segment.

Given the combination of the ultimate Disney character, in the hands of top specialists, and high production ambitions, it's hardly surprising that *The Sorcerer's Apprentice* became a high point of Disney animation. Understandably, animation art from this segment of *Fantasia* is much sought after by collectors, and prices reflect this. One key setup has sold for over $90,000, and other production setups have sold for more than $70,000. Even relatively modest animation drawings have commanded excellent prices, and it is safe to say that anything from this section of *Fantasia* rates among the most desirable items of Disney animation art.

The following segment—a fanciful chronicle of the story of evolution set to Stravinsky's *The Rite of Spring*—was less successful, the sometimes clumsy imagery being a poor match for the music. In part because relatively little art from this section of the movie has reached the marketplace, it has received only modest attention from collectors. The most collectible images from this section of the film are the cel setups of dinosaurs that have occasionally been offered for sale.

By contrast, the art associated with the fifth segment of

Fantasia—animated to a truncated version of Beethoven's Sixth Symphony (*The Pastoral*)—is extremely popular with collectors and a good deal of it is in circulation. This part of the movie evokes an art deco-ish version of a hybrid Arcadia in which character types from Greek mythology are given a decidedly American spin. The centaurs in this sequence are half horse/half high school football star, while the centaurettes are half pony/half cheerleader. The result is a highly decorative cuteness that offends some critics but is precisely what makes this segment so appealing to many collectors. Along with the preening centaurettes and strutting centaurs, the 20-minute sequence offers everything from a self-consciously adorable Baby Pegasus to Ward Kimball's hilariously bibulous Bacchus, and from saccharine-sweet cupids to Art Babbitt's suitably Olympian Zeus. Of special interest are the many fine concept paintings and storyboard sketches relating to the *Pastoral* segment, images that often show variations on the subject matter that appeared on screen, giving some idea of the kind of creative energy that went into *Fantasia*.

The *Dance of the Hours* segment, set to music by Ponchielli, is the most amusing part of *Fantasia*, a brilliant parody of classical ballet starring prima ballerinas such as Mlle. Upanova and Hyacinth Hippo, supported by a *corps* made up of hippopotamuses, elephants, ostriches, and alligators. Animation art from this section of *Fantasia* is understandably much coveted by collectors. The same is true of the images associated with the final segment of the movie, which was animated to Mussorgsky's *Night on Bald Mountain* and Shubert's *Ave Maria*. The first and longer segment of this section portrays an evil spirit in the form of Chernabog—a diabolical character drawn from Ukranian folklore—who awakens the demons and ghouls sleeping in a small gothic town. At dawn, these spooks return to their resting

places and torch-bearing pilgrims advance through a cathedral-like grove of trees, in tune with Schubert's peaceful music.

Much fine concept art from this section of *Fantasia* has found its way into the marketplace. Especially prized are animation drawings of Chernabog, who remains one of the most powerful presences in all of Disney animation. Like Stromboli in *Pinocchio,* Chernabog was animated principally by the great Bill Tytla who, like Mussorgsky, was of Ukrainian heritage and had a strong sense of the role of Chernabog in his nation's mythology.

Less than a year after *Fantasia* came *Dumbo*—a far more modest film but one that remains among the great favorites in the Disney canon. *Dumbo* was made largely because the studio was in financial trouble—*Pinocchio* and *Fantasia* had both lost money in first release—and it was a film that could be made relatively inexpensively (costing $812,000 in 1942 currency). The story is simple but, as Ward Kimball has been quoted as remarking, it has "cartoon heart"—the idea of a flying elephant is irresistible. With his huge ears, Dumbo is the ultimate underdog and his final triumph is so lacking in guile and vengefulness that it is especially satisfying.

As John Grant has pointed out in *Walt Disney's Animated Characters, Dumbo* is a movie that depends more than most upon vocal characterization—think of Timothy Mouse or the crows—but Dumbo himself has no voice and so is realized entirely in visual terms, a fact that helps make him a strong favorite with collectors. Almost any cel or drawing showing Dumbo catches an element of his character. As for Timothy, his Brooklyn accent (provided by Ed Brophy) was central to his personality, yet he too inspired some especially fine drawings and cels. *Dumbo* provided the basis for a number of fine Courvoisier setups, ranging in subject from Dumbo with his

mother and with the hipster crows to the celebrated pink elephant sequence.

Also much sought after by collectors are the Courvoisier setups derived from Disney's fifth feature, *Bambi*. Released in 1942, *Bambi* had actually been on the back burner since 1935 when Walt Disney read Felix Salter's 1929 novel and decided it would provide an excellent basis for an animated feature. Throughout the late thirties and early forties, a skeleton crew of supervising animators—including Mike Kahl, Eric Larson, Frank Thomas, and Ollie Johnston—would work intermittently on *Bambi* while remaining on call for other features. They studied animal anatomy and behavior and evolved a new approach to the medium in which any animator might be called upon to work on any character in any scene. (Traditionally animators had been assigned to individual characters.)

Real deer were brought to the studio, and cameramen were sent to film deer in the Maine woods, all in the name of a naturalism and authenticity that would be one of the hallmarks of *Bambi*. Equally important, however, was the fact that the movie told a simple and affecting story with plenty of emotional punch leavened with comic relief.

Bambi became the fifth Disney classic to appear in a five-year period and the animation art it spawned has understandably become highly desirable to collectors, with especially fine production setups selling for tens of thousands of dollars. The characters most sought after by collectors include Bambi himself, his future mate Faline, Thumper the irrepressible rabbit, and Flower the skunk. All of these can be found in production setups, Courvoisier setups, cels, animation drawings, storyboard sketches, and concept art—which for *Bambi* is particularly strong. The same can be said for the few production backgrounds that have reached the marketplace.

These first five Disney features—*Snow White and the Seven Dwarfs*, *Pinocchio*, *Fantasia*, *Dumbo*, and *Bambi*—set the standards by which all future animation would be judged. Their importance is unquestioned, and inevitably they have attracted a great deal of attention from collectors who wish to acquire examples of animation art at its very best.

8

Disney Features: The Middle Period

World War II, and the economic conditions that accompanied it, brought a temporary halt to the ambitious program of feature animation at the Disney studio. For several years, the emphasis returned to short cartoons—some of them made for the government and military services—though the period also saw the production of five anthology films. (These are movies made up of several self-contained parts that are linked by theme or concept rather than by a continuous narrative.) At least four of these anthologies are sometimes counted among the Disney features, which is perhaps appropriate since *Fantasia* is actually an anthology film, too, though conceived on an epic scale.

The first of the more modest anthology films was *Saludos Amigos*, released in 1943, a time when Latin American distribution had become important to the Hollywood studios. The European market had been virtually eliminated by the war.

With a group of studio artists, Disney toured several Latin American countries under the sponsorship of the State Department. Home movie–type footage was shot during this tour (artists sketching, Walt Disney learning a folk dance) and later, in Burbank, some of this was combined with four cartoon shorts to create a 43-minute mini-feature.

The animated sequences starred Donald Duck on a visit to Lake Titicaca, Pedro the little mail plane, Goofy as an Argentine gaucho, and a new character called Jose Carioca who teaches Donald to samba against Brazilian backgrounds that appear to be brushed in as the movie plays. Courvoisier setups were prepared from each of these segments, and a few studio setups also made their way to the marketplace. The animation is of special interest to the history-minded collector because these short segments utilized the talents of some of the studio's top artists, including Bill Tytla, Fred Moore, Ward Kimball, Milt Kahl, and Bill Justice.

The same is true of the full-length *The Three Caballeros,* released in 1945. For this compilation, Donald and José Carioca were joined by a trigger-happy Mexican rooster called Panchito who helps them pull together a collection of gags, narratives-within-narratives enlivened with clever visual puns, and segments of live action combined with animation. Among the new characters introduced were Pablo the Penguin and Little Gauchito. Cels and studio setups from this movie are relatively rare; Courvoisier setups are easier to find.

Although it incorporates self-contained segments such as the stories of Pablo and Little Gauchito, it could be argued that *The Three Caballeros* is not a true anthology film because it makes some attempt at using Donald and his pals to provide continuity. *Make Mine Music,* on the other hand, released in 1946, is an anthology film pure and simple, a fact that is

acknowleged when the movie is introduced as "A Music Fantasy in Ten Parts."

The ten segments utilized the vocal and instrumental talents of such stars of the day as Dinah Shore, Benny Goodman, Nelson Eddy, and the Andrews Sisters. Among the more memorable sections are *A Rustic Ballad* (the story of the feud between the Martins and the Coys), *Casey at the Bat, Peter and the Wolf, A Love Story* (featuring Johnny Fedora and Alice Blue Bonnet, two hats who fall for each other), *Opera Pathetique* (starring Willie the Whale, who wants to sing at the Met), and *A Jazz Interlude.* The latter uses Goodman's music as the background for an amusingly art-directed story about Fred Moore–inspired bobby soxers who appear to come to life, *Out of the Inkwell* style, as a pencil sketches them on a drawing pad.

Released in 1947, *Fun and Fancy Free* was another anthology combining live action and animated elements, the latter including an interesting vehicle for Mickey, Donald, and Goofy in the form of *Mickey and the Beanstalk.* Art from this segment has been popular with collectors; several setups have been sold for extremely high prices. In this respect, *Mickey and the Beanstalk* might be compared with *The Sorcerer's Apprentice* segment of *Fantasia.*

Melody Time, which appeared in 1948, was the last of these anthology films and the one some critics consider the best. Like its predecessor, it made use of both live action and animated elements. Strong animated sequences included *Johnny Appleseed, Little Toot* (the story of a tugboat), and *Pecos Bill.* Art from the last two has been especially popular with collectors.

Also high on the wish lists of many collectors is artwork from *Song of the South.* Released in 1946, this is essentially a live-action film but does contain fine animated sequences based on the *Tales of Uncle Remus* by Joel Chandler Harris.

Characters like Br'er Rabbit, Br'er Fox, and Br'er Bear were brought to life with a vitality that has seldom been surpassed. This film remained a favorite of many veteran Disney artists. The late Ken Anderson, for example, said of the animated sequences, "This is the kind of thing we do best." Certainly the artwork that has found its way to the market bears this out. Full production setups are especially desirable because the brilliance of the character animation is matched by outstanding background paintings styled by Claude Coats and Mary Blair.

During the years following the release of *Bambi*, Disney had been anxious to get back to the production of full-length narrative animated features. Many projects were discussed—*Beauty and the Beast* for one—but economics continued to prevent any of them from being realized. In 1949 the studio released a sort of B feature narrated by Bing Crosby and Basil Rathbone, in two segments: *The Adventures of Ichabod and Mr. Toad,* based on Washington Irving's *The Legend of Sleepy Hollow* and Kenneth Grahame's *The Wind in the Willows.*

Of the two halves, the one inspired by the Irving tale is by far the stronger, culminating in Ichabod Crane's flight through the woods as he is pursued by the legendary Headless Horseman, one of the best sustained fright sequences in the history of animation. On the other hand, despite excellent voice talent—Eric Blore as Mr. Toad is outstanding—*The Wind in the Willows* segment is disappointing: sketchy and underrealized, the animation sometimes subpar. There are reasons to suppose that Disney had hoped to use Kenneth Grahame's masterpiece as the basis for a full-length feature and, indeed, the story does cry out for a more sustained and detailed narrative. Highly collectible animation art came out of both halves of the film, however, and high prices have been obtained at auction for superior quality setups.

In 1950, with the studio's financial health improving, Disney

finally released another full-length sequential animated feature, the first in almost eight years. This was *Cinderella*, a classic fairy tale brought to the screen with Disney's practiced panache and sureness of touch. The archetypal structure of the traditional story remains intact, but Disney embellished it with secondary characters and comedic situations that made it come alive for contemporary audiences. This embellishment included a subplot involving the animals of Cinderella's household—Jaq and Gus the sympathetic mice, Bruno the dog, and Lucifer the evil cat—all of them pure Disney. *Cinderella* is not as fresh as *Snow White* or as technically brilliant as *Pinocchio*, but it is a fine animated movie, and it proved that the studio was capable of recapturing its old glories.

For a variety of reasons, many of the artists associated with the first five classics had by now left the studio, and it is instructive to look at the credits for *Cinderella*. Listed as directing animators are Eric Larson, Ward Kimball, Norman Ferguson, Marc Davis, John Lounsbery, Milt Kahl, Wolfgang Reitherman, Les Clark, Oliver Johnston Jr., and Frank Thomas. With the exception of Ferguson—a top veteran who would leave the studio in 1953—this list makes up the team that Walt Disney would soon designate the Nine Old Men, the group of character animators who would dominate the style of Disney animation for the next three decades. Their skills helped make *Cinderella* a popular film with collectors and, despite the fact that a good deal of art from this production has found its way into the marketplace, some high prices have been realized for prime-quality setups, especially those featuring Cinderella herself.

Although *Cinderella* was not a huge box office success, it did well enough to ensure the continuation of the feature animation program, even though the studio was by now relying more and more on live-action films to turn a profit. The next ani-

mated feature to reach the screen was *Alice in Wonderland,* released in 1951. It will be recalled that Walt Disney's Hollywood career had begun with the Alice Comedies, combining animation and live action, and there is evidence that he toyed with the possibility of repeating the idea at feature length on at least three occasions. (At different times, Mary Pickford, Ginger Rogers, and Luana Patten had all been slated to star.)

Finally it was decided to turn Alice into an all-animated feature with results that were disappointing, despite some lively moments. As visually inventive as it is, Lewis Carroll's book ultimately depends upon playfully intelligent wordplay and there is no way of bringing that to the screen. Almost inevitably, an animated Alice was an Alice without soul.

This has not hurt the film with collectors, however, and the art from *Alice in Wonderland* is extremely attractive. Some very fine setups have come on the market and the prices fetched have ranged from excellent to astonishing. One key setup, featuring Alice with the hookah-smoking caterpillar, sold at auction in 1990 for in excess of $80,000. Several other setups have sold for between $30,000 and $80,000.

Alice was followed two years later by another adaption of a British classic, James Barrie's *Peter Pan.* This was also a film Disney had long wanted to make, having obtained the rights in 1939. It transferred to the screen more successfully than *Alice,* largely because it was possible to open up Barrie's fantasy in ways that would be impossible on stage. This applies, for example, to the magical scene in which Peter leads the Darling children in a flight over nighttime London.

A challenge that had to be faced in this production was developing Tinker Bell as a visible entity. On stage she was traditionally represented by a spot of light, but that would not have worked successfully in the context of animation. The

character was entrusted to Marc Davis, who brought her to life as a nubile sprite, doing it so effectively that she quickly became thought of as one of the classic Disney characters, famously used to introduce the studio's long-running television series.

A good deal of *Peter Pan* material is in circulation, including some very fine setups. This film seems popular enough with collectors, though the prices realized have not for the most part matched those paid for the most sought-after *Alice* material. It should be noted too that *Peter Pan* appeared not long after the opening of Disneyland. Cels and cel setups were sold at the park in the early days and *Peter Pan* was one of the productions they were drawn from. This may help explain the fact that *Peter Pan* setups with photographic or lithographic backgrounds are not uncommon, as is the case with the next several Disney features. There is nothing wrong with such setups, of course, but the collector should be careful to establish whether the background is a production original or a reproduction, since that should make for a significant difference in price.

It had become evident that the scaled-down animation team led by Disney's Nine Old Men (who in the mid-1950s were in their mid-forties) was not going to be able to produce an animated feature every year, and for the next three decades it settled into a routine that would see an average of one animated feature released every three years. This is not to say that aspirations were scaled back. On the contrary, the next two films— *Lady and the Tramp* (1955) and *Sleeping Beauty* (1959)—were among the most ambitious ever undertaken.

Based on a story by Ward Green, *Lady and the Tramp* was yet another project that had been percolating since the thirties. This was a tale that could have lapsed into cloying sentimentality, but it was carefully handled by Disney and the story artists and

was never allowed to cross over into the area of cuteness: the film is consistently entertaining and moving without becoming mawkish.

Not a groundbreaker in terms of narrative or style, *Lady and the Tramp* represents a major technical breakthrough by being the first animated feature to take advantage of the CinemaScope format. This caused all kinds of headaches for the animators but led to some especially handsome art from a collector's point of view—the elongated panoramic backgrounds called for by the format made for dramatic cel setups.

Good setups from *Lady and the Tramp* are much sought after, and this is even more the case with *Sleeping Beauty*—this time made in the wide-screen Technirama format—even though the film itself is less satisfying.

As with *Alice in Wonderland, Sleeping Beauty* is an instance of the animation art being more interesting in some ways than what unfolds on screen. This has a great deal to do with the background stylings, which were largely the work of Eyvind Earle. Conceived in a self-consciously archaic style which might be described as Post–Pre-Raphaelite, the backgrounds imposed a rigidity on the art direction of the film that led to stiff animation (though Maleficent, the splendid villainess, actually benefits from the extreme stylization). The stylization that can be so irritating on screen, however, makes for striking animation art.

The next animated feature, *One Hundred and One Dalmations*—the first of a long string of movies to be directed by Wolfgang Reitherman—also saw a stylistic innovation, this one brought about by a remarkable technical development that was to be a factor in the appearance of Disney animation—and hence Disney animation art—until 1989's *The Little Mermaid*.

It was a technical advance that came from the fertile brain of Ub Iwerks. Since returning to the studio in the late 1930s, the

man who had drawn the original Mickey Mouse had become the resident technical wizard, helping develop systems like the multiplane camera for animation and overseeing special effects for Disney's live action films. It had occurred to Iwerks that much time and money could be saved if animators' drawings could be photocopied directly onto cels, thus eliminating the laborious work of inking—tracing the drawings onto the cels.

Working with the Xerox Corporation, Iwerks created a system—tested in a few scenes of *Sleeping Beauty*—that permitted black lines to be recorded on acetate. (Later it would be possible to do this with colored lines as well.) Without the system, it would have been almost impossible to make a film like *One Hundred and One Dalmations.* (The reproduction system permitted the animators to copy basic drawings over and over again in changing combinations, making it practical to do scenes with scores of spotted dogs.) The system also demanded a change in approach for art director–production designer Ken Anderson because the slick inking style that had evolved over the years could not be matched with xerographic lines.

Anderson came up with a style that might best be described as sketchy—the lines nervous and a little jagged. It was a style that many of the animators liked, since it preserved the spontaneous feel of their drawings. It was especially well suited to a character like Cruella de Vil, whom Marc Davis turned into one of the studio's most memorable villains. Walt Disney, on the other hand, hated the jagged look and was not reticent about expressing his opinion. For Disney, working on *One Hundred and One Dalmations* was a nightmare and he was greatly relieved when it was finished and released, in 1961, observing that he fully expected audiences to share his distaste. For once his instinct was wrong—the public loved the movie. Rather than being upset by the look of the film, audiences permitted themselves to be drawn into a well-structured narrative that

featured not only the splendid Cruella but also a lively cast of animal characters brought to life by the likes of Milt Kahl, Frank Thomas, Ollie Johnston, John Lounsbery, and Eric Larson. A hit from the first, *One Hundred and One Dalmations* has remained among the studio's most popular films, loved by several generations of children and collectors alike.

Like the xerography technique, Ken Anderson survived and would remain a key member of the team, working next on 1963's disappointing adaptation of T. H. White's *The Sword in the Stone*, a movie that has not enjoyed much popularity with audiences or collectors. Despite some good character animation, the film failed to capture the magic of White's text. It is perhaps the most extreme example of Disney's failure to fully succeed in translating specifically English literary material into the language of animation.

Another English classic, *Mary Poppins* (1964), contained animated sequences, but they are among the least interesting parts of the movie. The featurette *Winnie the Pooh and the Honey Tree* (1966), however, was an example of a successful attempt to adapt English material to the screen. It was a mistake to interpolate a gopher into Pooh's world, but otherwise Disney and his artists succeeded in finding the universal appeal of A. A. Milne's stories and transforming it into something cinematic. The first film was followed by *Winnie the Pooh and the Blustery Day* (1968) and *Winnie the Pooh and Tigger Too* (1974). These are enlivened by some of the best animation of the period—Milt Kahl's work on Tigger a prime example—and they have become favorites of collectors, though prices have remained fairly reasonable.

The next full-length animated feature—and the last one to be supervised by Walt Disney—was *The Jungle Book* (1967), among the most successful of the postwar films. Yet another British classic, Kipling's story was adapted for the screen with

both taste and imagination. Beyond that, it featured some of the best backgrounds of the middle period (styled by Al Dempster), first-rate voice talents (Phil Harris, Sebastian Cabot, Louis Prima, George Sanders, Sterling Holloway), and wonderful character animation. In *The Jungle Book*—as in all the best Disney features—character animation is balanced by other high-quality production values, such as superb art direction. This almost guarantees superlative cel setups and makes art from this movie extremely attractive to the collector.

The Aristocats (1970) was originally planned as a two-part television show until Walt Disney decided it had big-screen potential and, shortly before he died, gave the green light to upgrade the production to make it a theatrical release. It is a pleasant enough movie, in the tradition of *Lady and the Tramp* and *One Hundred and One Dalmatians,* and once again features superior character animation. The production values are less satisfactory, however, and this shows up in animation art from the movie, which tends to have a more schematic appearance than art from, say *The Jungle Book.*

The schematic look is even more evident in the animation art from *Robin Hood,* a movie that made only cursory use of effects animation. (It is effects animation that adds rain or fog or mysterious shadows—atmosphere, in short—to a film.) By 1973, when *Robin Hood* was released, the studio had begun to become conscious of the value of the drawings, paintings, cels, and cel setups deriving from their productions and therefore relatively few examples of work from the movies of the late seventies and early eighties found their way to the marketplace. Until the seventies, in fact, there had been no marketplace for animation art to speak of. Once it became apparent that there were serious collectors out there, willing to pay real money for Disney drawings and cels, the studio understandably became concerned about controlling the flow and value of

its copyrighted material. This meant that very little work from the charming and well-executed *The Rescuers* (1977) has ever been available to collectors; the same is true for the less satisfying but still interesting *The Fox and the Hound* (1981).

The Rescuers, a tale of public-spirited mice, is in many ways the last of the Disney movies to have been fully controlled by the generation of animators who cut their teeth on *Snow White*. *The Fox and the Hound* was transitional in that it was co-produced by Wolfgang Reitherman, and Frank Thomas and Ollie Johnston were among the supervising animators, but this was the last hurrah for the survivors of the Nine Old Men. New names—Glen Keane, Ron Clements, John Musker—that would be key the imminent renaissance of the mid-1980s now appeared in the credits. The style was still middle-period Disney, but the torch was in the process of being passed.

In 1984, the Disney studio would change hands and enter the Michael Eisner era, which will be discussed in the next chapter. When Eisner and his studio head Jeffrey Katzenberg took over, they found the animation department in disarray largely because of *The Black Cauldron*.

This movie had been planned as an ambitious opportunity to reassert the strength of Disney animation in the hands of the next generation of artists. The raw material, based on Lloyd Alexander's *Chronicles of Prydain* books, was promising, and there was plenty of new talent available. The movie does in fact feature some interesting animation, but unfortunately there was no leadership to give direction to the film, which lacks shape and a sense of purpose. Not surprisingly, it was panned by the critics and failed miserably at the box office.

This disaster could have spelled the end of Disney animation, but one man still believed strongly in its future. That man was Roy Disney Jr., nephew of Walt Disney and son of Roy Sr., Walt's brother and business partner. Roy Jr. had grown up at

the studio and later worked there as a producer of nature films and television documentaries. He was a professional with an insider's appreciation of what animation meant to the studio. His stock shares were crucial to winning control of the company for the group led by Michael Eisner. In return, he exacted a promise that he would be named to head the animation department. The promise was kept, and because of it the animation department found itself with just enough clout to stay in business long enough to move on to new glories.

9

THE DISNEY RENAISSANCE

When Michael Eisner's management team took over the Walt Disney Company, the animation department was politely told to leave its place of honor—the handsome 1940 Animation Building on the Burbank lot—and was assigned to an industrial park near Glendale. Many animators saw this as a warning. If the program was not turned around, and quickly, they might find themselves out in the cold. The animators had one great champion in the person of Roy Disney Jr. Soon Jeffrey Katzenberg was bitten by the animation bug too, and gradually new life was infused into Disney animation.

The first step was a modest but charming little movie called *The Great Mouse Detective*, a gloss on the Sherlock Holmes stories that had been in development by a group of artists who had become disenchanted with *The Black Cauldron*. Katzenberg gave the go-ahead to put the project into production if it could be brought in at a budget somewhat lower than what the ani-

mation department was accustomed to. Under the direction of John Musker, Ron Clements, Dave Michener, and Burny Mattinson, the result was a film, released in 1986, that displayed many of the old Disney virtues, such as strong story development and character animation, and did a remarkably fine job of creating the illusion of high production values despite the reduced budget.

This was a portent of things to come. As the Eisner era continued, the feature animation department would show that it had rediscovered the way to make good use of the full range of weapons in the animator's arsenal—elaborate art direction and special effects, for instance—weapons that had sometimes been neglected in the previous two decades. That was good news for collectors of animation art because it would ensure visually satisfying setups with strong characters, matched by fully realized backgrounds.

Before another all-animated feature was released, however, came an even more important film, the live action–animation combination *Who Framed Roger Rabbit,* in which the Disney organization joined forces with producer Steven Spielberg, director Robert Zemeckis, and the noted Canadian animation director Richard Williams.

Released in 1988, *Roger Rabbit* was a deserved critical and financial triumph. There are many positive things that could be said about this production—from both an artistic and a technological point of view—but from the perspective of this book the significant factors are that it linked the Disney name with innovative animation for the first time in years, and gave rise to some spectacular animation art. For the first time since the early days of Disneyland, a good deal of this art was offered to the collecting public after the movie was released. This was due to the fact that the Walt Disney Company and other principals

contracted with Sotheby's in New York to offer art from the film at auction. The resultant sale, held over two sessions in June of 1989, offered more than 550 production cels combined with a variety of backgrounds to make up 394 lots. The substantial success of the sale set the stage for future auctions of current Disney material at Sotheby's.

Given the nature of the movie, the majority of the backgrounds were photographic, and live action characters such as Bob Hoskins's Eddie Valiant are featured along with Roger and Jessica Rabbit, Baby Herman, Benny the Cab, and the other animated characters. These "other" animated characters included many of Disney's well-established stars and featured players, from Mickey Mouse to Tinker Bell, as well as their opposite numbers from other studios, such as Bugs Bunny, Daffy Duck, Sylvester, and Betty Boop, appearing in cameo roles by special arrangement.

The next all-animated feature, *Oliver & Company*, was released in November 1988, just five months after *Roger Rabbit* made its debut. Based on Charles Dickens's *Oliver Twist*, *Oliver & Company* was another well-made, modest movie—like *The Great Mouse Detective*—which did not generate the kind of blockbuster attention that might have justified it becoming the focus of an auction. The 1989 release *The Little Mermaid*, on the other hand, immediately caught the fancy of the public and was proclaimed by critics to be conclusive evidence that a renaissance in feature animation was by now a reality at the Walt Disney Company.

Early Disney features, such as *Snow White* and *Dumbo*, can be considered to have been musicals, enhanced by songs that created atmosphere and moved the narrative along. This was occasionally true of the middle-period features as well—*Jungle Book*, for example—but all too often in the sixties and seventies

the Disney films became more like situation comedies punctuated by songs that did little to propel the action.

The Little Mermaid revived the tradition of the true Disney musical. For this film, Jeffrey Katzenberg and Peter Schneider—who now ran the feature animation department on a day-to-day basis—brought in the gifted song-writing team of Howard Ashman and Alan Menken, till then best known for their brilliant musical version of *Little Shop of Horrors*. Ashman in particular was a longtime Disney buff who soon became a key member of the creative team, pushing the directors—John Musker and Ron Clements—toward making *The Little Mermaid* a true animated musical and instant classic.

Musker—who co-produced the film with Ashman—and Clements welcomed this input, and the result was a film that showed that the new generation of Disney artists was capable of distancing itself from the influence of the Nine Old Men (while continuing to have the greatest respect for them). *The Little Mermaid* is very much a product of youthful creators, full of fun, wit, and fresh energy. This shows in the animation art, 283 lots of which were auctioned at Sotheby's in December 1980, all consisting of production or pre-production art. Again the sale was a resounding success.

In one sense, *The Little Mermaid* was the first film of the Disney animation renaissance. At the same time, however, it was the last film of an era in that by the time the next animated feature went into production a tremendous shift in animation technology had taken place at the Disney studio—one that would have a major impact on the movies themselves and on the art that would be made available to the public. The Disney front office had by now realized that feature animation still had great potential for generating box office business and approval was given for the considerable capital expenditure needed to

update and upgrade the feature animation department. The greatest investment was in creating a computer system that would streamline production. The resulting CAPS system is in fact a marvel of dedicated computer technology that not only speeds up production (thus saving money) and improves image quality, but also enables directors, production designers, layout artists, and animators to do things that have never been done before.

It also, unfortunately, led many fans to the mistaken belief that Disney had now entered a new phase in which entire movies could be animated by computer. True, a minimal amount of computer animation has been used in recent Disney films—the stampede in *The Lion King*, for example—but this only accounts for a tiny percentage of what reaches the screen, and none of that is character animation.

In reality, the new generation of Disney character animators—Andreas Deja, Glen Keane, Eric Goldberg, and Ruben Aquino, to name just a few of the most outstanding—work in exactly the same way that their forebears did at the time of *Snow White* and even earlier. In other words, they animate the characters by hand, using a pencil on sheets of animation paper. The layout drawings are also still made by hand, and the backgrounds based on those layouts continue to be painted by hand.

What has changed is the way in which these elements are combined. In the old days, the drawings were traced or photocopied onto cels which were then painted and placed over the backgrounds to be shot frame by frame by the animation camera. With CAPS, all these different elements are scanned into the computer, where they are assembled into images that are transferred electronically to film, without the intervention of a conventional camera. Among the advantages of the system is

the fact that schematic versions of a scene—made up of animation drawings and layouts—are available for viewing long before the characters have been colored or the background painted. Another advantage is that enormously complicated scenes can be created that would have been inconceivable under the traditional system, both because of the labor involved and because of the impracticality of shooting clear images made up of many layers of cels.

With CAPS—or any other computerized production system—there is no acetate, making the cel a thing of the past. Almost all of the backgrounds are still painted by hand, but where character animation is concerned, the color is added electronically (by retrained members of the Ink and Paint Department) after the pencil drawings have been scanned into the system. This includes the coloring of lines, permitting subtleties that had not been seen in animation since the pre-xerography era. The point, though, is that with CAPS there is no stage at which anything resembling the final on-screen image has a physical existence outside the computer.

What, then, would become of the idea of animation art as a collectible? By now this was of considerable concern to the studio since the *Roger Rabbit* and *Little Mermaid* sales had proven that animation art could generate significant revenue. This became a compelling issue with the 1991 release of *Beauty and the Beast*, a smash hit with critics and audiences alike.

As noted in Chapter 3, Disney had already marketed re-creations of classic cels using the talents of ink and paint veterans. These veterans were called in now to create cels for a movie that was made without cels. In the case of *Beauty and the Beast*, for example, they were asked to create cels for setups—some of them very elaborate—using every production background employed in the film. The drawings were selected by

the heads of the Ink and Paint Department and the cels were created under their supervision. In a sale that matched the success of the movie itself, 249 of the finished setups were auctioned at Sotheby's. Others were made to be preserved by the Disney animation research library for in-house purposes, ranging from exhibitions to study by animators.

Some observers have objected to the notion of creating cels that in fact have no role in the actual production of the movie. Certainly it is important for the collector to realize exactly what he is purchasing (and this is clearly explained in Sotheby's animation art catalogues). In practice, similar cels could be produced by wholly mechanical means, but few collectors would find such creations acceptable. Instead, they prefer handmade cels that keep an honorable craft—part of the history of animated film—alive when it might otherwise become obsolete. Then again, the backgrounds used in the setups—often masterful in their own right—are authentic artifacts from the actual production. Thus the collector is purchasing genuine production art.

There is a precedent for this. What you have, in the CAPS era, is in fact the reverse of the Courvoisier setups of the 1930s, '40s, and '50s in which the cels were genuine production art while the backgrounds were created after the fact.

Setups using the combination of specially prepared hand-painted cels with production backgrounds have been auctioned after every animated feature since Beauty and the Beast. They should not be confused with the editions produced in connection with the same films in which hand-painted cels are combined with lithographed reproductions of backgrounds.

Because the CAPS system permits complex staging of scenes, the setups derived from the movies that employ it are often extremely rich. And because CAPS challenges the artists

to create new effects, the setups are also sometimes highly atmospheric. This is certainly true of *Beauty and the Beast*. The climactic battle between Gaston and Beast, for example, is represented by at least half a dozen striking setups that successfully evoke the drama of the moment, complete with driving rain.

The same policy of producing hand-painted cels to match up with production backgrounds has continued with the succeeding Disney animated features, *Aladdin, The Lion King, Pocahontas, The Hunchback of Notre Dame,* and *Hercules.* Thus, all of these films have produced handsome animated art as a by-product. Indeed, the emphasis on production values that marks these movies has made for some of the most striking images ever to be generated by the medium. One thinks, for example, of Aladdin and Abu in the Cave of Wonders, of Simba and Nala in the elephants' graveyard, of Pocahontas in her bark canoe navigating the waterways of the virgin forest, Quasimodo peering out from his tower at the bustling panorama of Paris. Thanks to Disney's cel-painting program, these and other great scenes have been preserved in a way that permits them to be framed, studied, and enjoyed at leisure.

It has also been a practice, at each of the Disney-Sotheby auctions, to offer a limited number of the three-dimensional animation maquettes that were used in the production of the film. Each about the size of a Barbie doll, these were produced for the animators to keep in their studios for the purpose of observing the characters from different angles. Although not seen on screen, they are authentic tools of the various productions, modified for collectors by having been hand-painted by members of the Ink and Paint Department.

Each of the recent animated features has its own distinct character, rooted in the studio's traditions yet continually

demonstrating that the new generation of Disney artists has something new to bring to the animation table. Directed by Gary Trousdale and Kirk Wise, and produced by Don Hahn, *Beauty and the Beast* (1991) combines melodrama and restrained comedy with great panache, offering us Belle, an intelligent and spunky heroine (one of the hallmarks of recent Disney films), an unusual villain in the form of Gaston (who at first seems more of a preening oaf than an out-and-out bad guy), and a splendidly conceived grab bag of conflicting emotions concentrated into the character of Beast, whose grotesque appearance perfectly encapsulates his uncontrollable rage. The animation art auctioned by Sotheby's reflects the grandeur of the film. Beast tends to be less effective in still images than in motion on-screen, but Belle and Gaston are well represented in cel setups, as are supporting characters such as Mrs. Potts the teapot and Chip her tea cup son, and especially Cogsworth and Lumiere, the talking clock and the expressive candle holder.

If *Beauty and the Beast* is an emotional roller coaster, *Aladdin* (1992) is a deliberately light and airy blend of fantasy and slapstick, highlighted by moments of visual magic and the bravura performance of the Genie, animated by a team led by Eric Goldberg and enormously enhanced by the vocal pyrotechnics of Robin Williams. This film features the last songs writen by Howard Ashman and Alan Menken before Ashman's death. Since Ashman was too ill to produce, this chore was left in the able hands of John Musker and Ron Clements, who also directed. *Aladdin* yielded striking animation art, with Aladdin, Jasmine, Genie, and the evil Jafar being especially strong characters, and many of the backgrounds displaying a powerful exoticism.

Until 1993, all Disney animated features (not counting anthology films) had been based on existing material in

another medium. *The Lion King* departed from that precedent in that it was scripted and storyboarded from scratch, the basic idea having originated, it seems, with Jeffrey Katzenberg. It was also the first Disney feature to completely ignore the human world by being cast entirely with animal characters. (No humans are seen in *Bambi*, but their presence is strongly felt in the impact of fire and firearms on the forest creatures.)

Produced by Don Hahn, and directed by Roger Allers and Rob Minkoff, *The Lion King* successfully evokes a world in which the virtual absence of conventional props—Rafiki's staff is a rare exception—presented the animators with special problems. (In most animated movies you can keep a character's hands occupied by inventing some business with a cane or a cigar or some other object—Jiminy Cricket's umbrella in *Pinocchio* is a good example. Props help greatly in the creation of the illusion of life. Take those props away and that illusion is much more difficult to achieve.) *The Lion King* also takes advantage of a strong story line, rooted in parental love and the challenge of achieving maturity. As usual there is a notable villain, in the form of Scar, and effective comedy relief is supplied by Timon the meercat and Pumbaa the warthog. Sotheby's sale of *Lion King* animation art was extremely successful, which is hardly surprising since the film broke all box office records for an animated feature and the artwork offered was of high quality. Setups highlighting all the major characters and many of the backgrounds offered in these setups were extremely striking.

Pocahontas, released in 1995, was less successful at the box office and in the salesroom—though by ordinary standards it did quite well in both locales. Since *The Little Mermaid*, the Disney films had been attracting adult audiences, a feat that had been achieved without losing the children's audience that

had always supported Disney animation. It seems possible that in the case of *Pocahontas* the studio miscalculated by producing a film that was tilted too far toward the adult audience. The native American heroine herself appealed to adolescent and preadolescent girls, but otherwise the movie had little to offer youngsters. The fact that *Pocahontas* was less successful than its three predecessors means that the collector who is not a slave to box-office indicators may well find relative bargains among the work the studio released for auction. This film featured some powerful images, ranging from the storm at sea experienced by the English colonizers to the wilderness that the Native Americans call home. It seems possible that *Pocahontas* material may well increase in value as time passes.

The Hunchback of Notre Dame (1996), based on Victor Hugo's great novel, was also geared largely to adult audiences, and some critics felt that it failed because it is the kind of story that is best made as a live-action film. That said, it is a visually powerful film in which medieval Paris is brought to life in one striking image after another. The imagery is so memorable that this film may prove to be a favorite with collectors in the long run, despite its failure to match the blockbuster box office success of predecessors like *The Lion King.* Such a pattern would not be unprecedented. Far bigger box office failures, such as *Sleeping Beauty,* are now looked on as masterpieces.

Hercules (1997) opened to generally mixed reviews. A fantasy-comedy in the spirit of *Aladdin,* this promises to be a picture that will have appeal for future collectors. This is likely to be even more true of *Mulan* (1998), the best Disney feature since *The Lion King.* Because of its exotic setting, *Mulan* is full of striking visuals of the sort that make an animated movie memorable. Disney continues to produce one animated feature a year, but the size of the Disney animation department has

increased—with branches in Florida and France, and a brand-new headquarters in Burbank—to the point that in the future the studio may well be in a position to release two features a year.

Whether this would be a smart move from a theatrical point of view is open to question. From a collector's perspective, however, it is welcome news that the Disney tradition appears to be alive and well. Fresh animation art in the studio's inimitable tradition is likely to come on the market at regular intervals.

10

THE WARNER BROS. TRADITION

By the time *Snow White* was released in 1937, Disney artists were looked upon as the aristocracy of the animation world. But over at Warner Bros., at around the same time, several talented animators, including Chuck Jones, Bob Clampett, Frank Tashlin, Friz Freleng, and Tex Avery, were beginning to establish their own reputations. They weren't interested in trying to imitate the style of the Disney elite. Rather, they were well on their way to becoming the archetypal anarchists of the cartoon medium.

They were also on their way to having a justifiable claim to being the ultimate masters of the animated short. Nothing can diminish the achievement of the Disney studio in this area—for at least a decade following Mickey's debut, it ruled the territory. But for almost a quarter of a century, starting in the late 1930s, the Warner Bros. animation department produced a string of hilarious shorts, the best of which are as entertaining

and clever as any ever made, still full of life and vitality today, as is evident from their continued popularity on the small screen. Collectors were slower to appreciate the animation art from these films than that spun off by the great Disney features, but in recent years Warner Bros. imagery has begun to find its appropriate level in the marketplace.

The beginnings of Warner Bros. animation were not particularly auspicious. Hugh Harman and Rudolf (Rudy) Ising were members of the Kansas City team Walt Disney had brought out to California in the mid-1920s. Ising left Disney in 1927, and Harman followed soon after. In the wake of the success of *Steamboat Willie*, they joined forces to produce their own series of talkie cartoons. Their first effort was a test reel called *Bosko, the Talk-Ink Kid*, starring a character who, despite later denials, was decidedly blackface minstrel in appearance. (Perhaps not too surprising, since he was conceived in the heyday of Al Jolson.) Although this reel was never shown theatrically, it was seen by Leon Schlesinger, then head of Pacific Art and Title, a company that during the silent era produced title cards for movies. Schlesinger was on friendly terms with the Warner brothers, having been one of the backers of *The Jazz Singer*, the movie responsible for making their studio one of the majors. He persuaded the Warners to distribute a series of cartoons made by Harman and Ising and produced by himself.

From its 1930 debut, this series was called Looney Tunes, a name devised by Harman and Ising (who naturally enough called their own company Harman-Ising). The original star of this series was Bosko, sometimes joined by his girlfriend Honey. The films were not bad by the standards of the period, but as Leonard Maltin has pointed out in his history of animation, *Of Mice and Magic*, Harman and Ising lacked the vision and drive of Walt Disney, so there was little evolution from one Looney Tune to the next. Still, they were quite popular with

audiences and their box office success led to the 1931 launching of another series, this one designated Merrie Melodies, which was somewhat based on the Disney Silly Symphonies and devoted to showcasing musical material copyrighted by the Warner music company houses.

Animation art from these early Warner Bros. cartoons is extremely rare. Anything relating to the Bosko films is considered especially desirable because it has great crossover appeal, being sought after by both animation collectors and collectors of African-American kitsch.

In 1933, Harman and Ising dissolved their relationship with Schlesinger and Warner Bros., taking Bosko with them. According to Steve Schneider in his 1988 study, *That's All Folks,* Schlesinger was left with little but the rights to the names Looney Tunes and Merrie Melodies. Undismayed, he rented a building on the Warner Bros. lot, brought over two more Disney veterans—Jack King and Tom Palmer—and made them directors. More important, he also promoted Friz Freleng, who had earlier come from Disney, to the rank of director, while strengthening the animation team with talented people like Clampett, Chuck Jones, Virgil Ross, and Chuck Sutherland.

Still, there was some distance to go before Warner Bros. released the studio's first memorable cartoon. For a while the young animators labored on Looney Tunes starring a drab couple dubbed Buddy and Cookie, sometimes described as "Bosko and Honey in white face." The Merrie Melodies meanwhile fared slightly better, if only because, beginning in 1934, Schlesinger began to produce them in two-strip Technicolor, which was less naturalistic—it used only red and green—than the three-strip system already in use at Disney but effective nonetheless.

Friz Freleng directed many of the best Merrie Melodies. These films took advantage of the excellent Warner Bros. music

library, and Freleng had a flair for matching animation with music, though he was also adept at slapstick. In 1935, almost inadvertently, he came up with the studio's first real cartoon star in the form of Porky Pig, who made his debut as one of several barnyard characters—animal variants on the Our Gang regulars—in a film called *I Haven't Got a Hat*. Porky was required to recite "The Midnight Ride of Paul Revere," which proved disastrous thanks to his unfortunate stammer. In the present climate of political correctness, such a character would be unconscionable, but in fact Porky was not simply an object of ridicule since his speech disorder was treated in such a way as to make him seem like a sympathetic underdog. Despite his predilection for pratfalls and the ridicule they engender, Freleng had a way with underdogs.

Tex Avery joined the Schlesinger team at about this time and used the Porky character in his first Warner Bros. outing, *The Gold Diggers of '49*, a parody of Busby Berkeley movies. Avery's sense of humor was wildly inventive and when Chuck Jones and Bob Clampett were assigned to his unit, the Warner Bros. style really began to take shape. Porky was redesigned and given more important roles to play. Other directors, such as Frank Tashlin—who would later make his reputation as a live-action director—took on the challenge of coming up with a benign kind of lunacy that led to the production of zany cartoons with punning titles such as *The Petrified Florist, Wholly Smoke,* and *Little Pancho Vanilla*.

Two new names—Carl Stalling and Mel Blanc—began to appear on the credits in 1936 and 1937, respectively, and although neither could draw, each made a major contribution to the Warner Bros. idiom. Blanc, as most people know, was the man of a thousand voices. He took over the Porky character and eventually lent his vocal talents to almost every major

Warner Bros. cartoon personality. (Elmer Fudd, performed by Arthur Q. Bryan, was the one notable exception.) Stalling, it will be remembered, had been Disney's first musical director and, after a spell at the Ub Iwerks Studio, spent the remainder of his career providing music for the Warner Bros. stable of characters. Over a period of twenty-two years, he produced scores for more than six hundred cartoons, also conducting the Warner Bros. orchestra, members of which are reported to have taken a special pleasure in recording tracks for the animation department. Like Blanc, Stalling was an indispensible contributor to the studio's anarchistic style; his musical wit was a perfect match for the visual humor of the animators.

The next Warner Bros. cartoon star to emerge was Daffy Duck, who like Porky was built around a speech defect. According to studio legend, the voice given to Daffy was a slightly exaggerated approximation of Leon Schlesinger's own—a fact that, not surprisingly, he never acknowledged. Daffy made his debut in the 1937 Tex Avery–directed short, *Porky's Duck Hunt,* in which he had a minor role. The following year he was given the lead in a couple of shorts, including *Daffy Duck in Hollywood*—and the rest is history. By the time he was featured in *You Ought to Be in Pictures,* in 1940, Daffy Duck was an established star.

Bugs Bunny, probably the most celebrated of all Warner Bros. characters, made a debut of sorts in the 1938 cartoon *Porky's Hare Hunt,* which was directed by Ben Hardaway, whose nickname was "Bugs." *Porky's Hare Hunt* was in fact *Porky's Duck Hunt* with a rabbit replacing Daffy. The rabbit even behaved like the prototype version of Daffy and was referred to at the studio as "Bugs' bunny"—in other words, the rabbit featured in "Bugs" Hardaway's film. This maniacal and primitive incarnation of the rabbit was used in a couple more

cartoons before undergoing the transformation that would make Bugs a superstar.

Afficionados insist that the true Bugs, replete with Brooklyn accent and street-smart style, didn't hit the screen until 1940 when Tex Avery directed him in *Wild Hare,* the movie that marked the debut of the catchphrase, "Eh, what's up, Doc?" (not to mention Elmer Fudd's "Be ve-wy, ve-wy quiet, I'm hunting wabbits").

Even then, Bugs had not found his ultimate form, undergoing several makeovers before Robert McKimson—then an animator in Bob Clampett's unit but later a top Warner Bros. director—prepared a model sheet that helped define the superstar's ultimate persona.

Other classic Warner Bros. characters include Tweety Bird, first seen in *A Tale of Two Kitties* (1942); Yosemite Sam, *Hare Trigger* (1945); Sylvester, *Life With Feathers* (1945); Pepe LePew, *Odor-able Kitty* (1945); Foghorn Leghorn, *Walky Talky Hawky* (1946); Wile E. Coyote and the Road Runner, *Fast and Furry-ous* (1947); Marvin the Martian, *Haredevil Hare* (1948); Speedy Gonzales, *Cat-Tails for Two* (1953); and the Tasmanian Devil, *Devil May Hare* (1954). Some of these characters belonged almost exclusively to a single director. Chuck Jones created and shaped the Road Runner films, for example. According to his own account, he and writer Michael Maltese thought that it would be amusing to do a parody of chase cartoons. So successful was their first effort that the series that followed was entrusted entirely to Jones and his regular crew.

Other characters were developed collectively, with just about the entire team having a hand in the evolution of Bugs and Daffy, for instance. Sylvester and Tweety as a team belonged to Friz Freleng, but Sylvester alone was available to other directors for use in different situations—for example, the cartoons in which Sylvester tries to impress his son but finds

himself confronted by Hippety Hopper, a "giant mouse" who is actually a baby boxing kangaroo. These were a speciality of Robert McKimson.

Freleng, Jones, Avery, Clampett, Tashlin, and McKimson were all notable animation directors—genuine *auteurs*—and since there were no features produced by the Warner animation department, they could devote all their considerable talents to exploring the possibilities of the one-reel cartoon. (By the fifties cartoons were often only six minutes long to accommodate the needs of theater owners.) They became supreme masters of economy, skilled in finding the essence of every gag and squeezing the most out of it. Each had a distinctive sense of style, and that sense of style was defined to a large extent in terms of timing. Jones has said that he timed gags down to a single frame of film, and it is easy to believe this. It is probably true of the others, too, though each would have had his own opinion as to which frame to cut. Just how long one director holds Bugs's double take is what differentiates that person's style from someone else's.

It is this sense of timing that makes the cartoons work as cartoons. It also has an impact upon the individual examples of animation art from that cartoon. This is of primary interest to collectors because timing influences the way the animators approach a particular scene. If the director's sense of staging dictates that Sylvester's lunge for Tweety should occupy twenty frames rather than twenty-four, it will cause the animator to show what he has to show with fewer drawings. This will tend to make some of the drawings—the "extreme" drawings—more dramatic. The individual drawing—or the cel traced from that drawing—is therefore likely to capture more of the spirit of the action. Thus, movies that are most striking on-screen often tend to produce the most striking animation art.

The first important period in Warner Bros. animation might

be said to have lasted from Porky's debut in 1935 to about 1944 when the studio finally bought the animation unit (until then it had technically belonged to Leon Schlesinger, Warner being the distributor). That period is marked by the rapid evolution of both style and characters and is dominated by the directing talents of Avery (who departed in 1942), Clampett (who would leave in 1946), Tashlin (who left in 1938 but returned for a two-year period in 1944), Freleng (who hung around for the glory days), and Jones (who began directing in 1938).

As already noted, Avery's approach was exorbitantly innovative. He set the standard for the fast pacing that characterized Warner cartoons and pioneered other trademark devices, such as characters addressing the audience directly. In cartoons like *Thugs with Dirty Mugs* he actually creates the illusion of interaction with the audience by having animated silhouettes of supposed moviegoers superimposed over the action with suitable soundtrack commentary. Along with Tashlin, Avery was one of the first to put the voiceover narrator to comic use, most notably in a series of cartoons that parodied the travelogues that were then a standard feature of movie programs. Add to this the fact that he was the person who made Bugs Bunny a star and his importance in the evolution of the Warner studio will be obvious.

Bob Clampett's particular genius was for creating cartoons that took full advantage of the medium's potential for defying the laws of gravity and logic. The structure of a short like *Porky in Wackyland* (1938) is far more free-association fantasy than traditional story, with Wackyland proving to be full of surreal creatures, such as the two-headed beast—half dog, half cat—that fights with itself. Clampett often took the studio's standard characters into a Freudian dreamland, as in *The Great Piggy Bank Robbery* (1946) in which Daffy experiences a nightmare that sees him subjected to the persecution of villains out of a

grotesque version of Chester Gould's *Dick Tracy* strip. Predictably, Clampett's version of Bugs Bunny was notable for being deliriously aggressive, as well as displaying a penchant for appearing in drag, which was taken up by other directors. Clampett also had an original way with celebrity caricature movies, notably in *Book Review* (1946), which features likenesses of Benny Goodman, Frank Sinatra, and Jimmy Durante, and has Daffy Duck doing an impersonation of a zoot-suited Danny Kaye.

Frank Tashlin was almost too versatile for his own good. His reputation as a gag writer—he worked for Hal Roach and the Marx Brothers among others—equaled his reputation as an animator. He also produced many newspaper cartoons and eventually became a major live-action director. His contribution to animation should not be overlooked, however. Like Tex Avery, Tashlin made a practice of using quick cuts to give his cartoons pace, and also like Avery he enjoyed playing games with audiences' expectations, setting up arguments between on-screen characters and the voiceover narrator, for instance. So far as the standard characters were concerned, he was especially strong with Porky Pig and Daffy Duck.

Jones would have his greatest success from 1945 on (see chapter 11), but in this early phase he had begun to establish himself with cartoons like *Old Glory* (1939) and *Inki and the Lion* (1941). The latter tells the tale of "Little Red Riding Hood" from the point of view of the wolf. The former combines live action with animation to portray Porky's adventures when he takes Daffy's advice and quits Warner Bros. to seek greater fame and fortune with another studio.

Since there was no Walt Disney imposing a house style at Warner Bros., each of these directors really was in charge of his own films, so that it is appropriate to talk of a Tex Avery cartoon or a Friz Freleng short. At the same time, though, the units

interacted and played off one another so that the characters evolved almost independently of the directors. For the collector, it is fascinating to trace how this is expressed in the animation art that has reached the marketplace.

It is possible, for example, to have a record of how Bugs Bunny evolved from a somewhat stunted bumpkin to the confident and svelte superstar we all know. It should be noted, however, that animation art related to the "wascally wabbit" tends to be expensive. This is especially true for early examples, since most early Warner Bros. art was destroyed because it was thought to be taking up too much storage space. Luckily, artists occasionally took drawings home, and just as Walt and Roy Disney gave away presentation cels to visitors to the studio, so Leon Schlesinger handed some out as gifts. He also had cels specially prepared and mounted on monochrome boards or schematic backgrounds as part of a short-lived scheme to market Warner Bros. animation art. These came printed with the "handwritten" inscription, "This is an original painting that I used in a 'Looney Tunes' and 'Merrie Melodies' copyright Leon Schlesinger." Some feature standard characters like Porky and Daffy and a few of the early examples are in black and white. All are highly sought after.

In general, Warner Bros. material of the thirties and early forties sells in much the same range as comparable examples from the Disney shorts of the same period. Given the fact that good examples are significantly rarer than is the case with Disney material, it is reasonable to assume that early Warner Bros. animation art will only appreciate in value.

11

LATER WARNER BROS.

It was during World War II that Warner Bros. cartoons really took on a clear identity for American audiences. Given wartime conditions, the anarchic attitudes of a character like Bugs Bunny were perceived as patriotic bravado, an all-American boy showing the Axis powers that he could not be intimidated by dictators of whatever persuasion. In Friz Freleng's 1945 *Herr Meets Hare,* Bugs torments Hitler and Hermann Goering by impersonating, among others, Joseph Stalin and Brunhilde.

Not that every wartime Bugs Bunny cartoon had this specifically propagandist tone, but all of them gave the notoriously nonchalant rabbit an opportunity to thumb his nose at some institution or another, even the animation industry itself, as in the case of Bob Clampett's *A Corny Concerto* (1943), which provided Bugs with a priceless opportunity to poke barbed fun at the pretentious aspects of *Fantasia.*

All of the Bugs Bunny cartoons—with a couple of early and

misbegotten exceptions—presented the rabbit as a winner, casually munching on a carrot just as a G.I. might chew on a cheroot. Stefan Kanfer, in *Serious Business*, his idiosyncratic history of the animation industry, has noted that members of the armed forces wanted—for obvious reasons—to feel in control of each and any situation, so that Bugs, who "could outrun bullets and outalk the enemy," made a perfect unofficial mascot. It is for precisely the same reason, one suspects, that kids love Bugs to this day. It has a great deal to do with the reason that collectors continue to put a high premium on the image of Bugs Bunny. To own an animation drawing or cel of the resilient rabbit is to possess a little piece of his cheeky infallibility.

Another Warner Bros. character to come into his own during World War II was Daffy Duck, finding his mature—if that term may be applied to such severe personality disorders—persona in cartoons themed to the conflict, such as *Scrap Happy Daffy* (1943), *Draftee Daffy* (1945), and in standard civilian Warner Bros. romps such as *The Henpecked Duck* (1941) and *Porky's Pig's Feat* (1943). Able to move with ease from withering scorn for "suckers" to abject, cringing self-pity, Daffy would become a perfect foil for Bugs, though in the early forties he was more often paired with Porky, who served well as the archetypal sucker.

The wartime period saw the production of some amazing Warner cartoons—Freleng's *Rhapsody in Rivets,* Clampett's *Russian Rhapsody* and his version of Dr. Seuss's *Horton Hatches the Egg*—that were not keyed to the standard characters. By VJ Day, the Warner animation department was a force to be reckoned with in the industry. Its style had been well attuned to the mood of the war years, but in some ways it was even more suited to the cocky and confident America of the postwar era.

From 1946 on, Warner Bros. animation was divided into three units, one headed by Friz Freleng, one by Chuck Jones,

and the third by Bob McKimson. It was these three, greatly supported by story men like Mike Maltese, Tedd Pierce, and Warren Foster, by skillful art directors, and by a gifted team of animators, who were responsible for Warner's golden age. Character animation is generally looked upon as the special province of the Disney studio, and certainly it is there that it has been most thoroughly and richly explored. The Warner Bros. animators were entirely capable, however, of cleverly utilizing their own brand of character animation to make the most of a blustering loudmouth like Yosemite Sam, a rancid Romeo like Pepe LePew, or a pompous windbag like Foghorn Leghorn. The way the cartoons were made had a great deal to do with this—they were directed in a hands-on way. It is reported that Chuck Jones, for example, habitually made a couple hundred preliminary drawings for each one-reel movie to show exactly how he wanted the characters to behave in each scene.

Critic Manny Farber once wrote of this studio's cartoons, "The aim is purely and simply laughter." There are many ways of provoking laughter, however, and the Warner product ran the gamut from the wordless duels of Wile E. Coyote and the Road Runner—with their preordained outcomes—to the verbal humor practiced by Bugs. If Bugs, Road Runner, and Tweety were indestructible winners of the cartoon universe, they were balanced by a whole spectrum of equally indestructible losers, including the supremely gullible Elmer Fudd, Sylvester (so adept at outsmarting himself), and Daffy, with his unique ability to transform paranoid delusions into something almost heroic.

The remarkable thing about the classic Warner Bros. cartoons is that they are so durable. The gags planted in *Ain't She Tweet* (1952) and *Hopalong Casualty* (1953) are designed to take the audience by surprise the first time around, and they do, but the amazing thing is that they work even better on a second view-

ing, and continue to work no matter how often they are seen. In some magical way, surprise is transformed into anticipation and the gags remain funny *because* we know they are coming. Often, in fact, the Warner Bros. directors worked with this in mind, as is apparent in movies as varied as those in which Sylvester is pitted against Tweety and those in which Wile E. Coyote is discovered plotting the downfall of the Road Runner. When Wile E. constructs an ACME rocket backpack to lauch himself in pursuit of his nemesis, we *know* that his efforts are doomed. The laugh comes—again and again—from the wit and skill with which the disaster is staged. Sometimes, watching the start of a Warner Bros. cartoon for the umpteenth time, we get a kick simply from remembering just how funny and clever it is.

This shock of recognition spills over into the field of collecting. A single drawing or cel from a Warner Bros. cartoon of the golden age (c. 1943–1959) often captures the feel of an entire movie, an entire era. This is especially true as the art direction became bolder, beginning in the late forties, so that the influence of layout artists like Maurice Noble and Hawley Pratt is felt along with that of the directors and animators, making for a sense of place and time that was unique to the products of this studio.

Formidable comedic invention and cleverness is to be found in the work of all three Warner Bros. units. As noted in the last chapter, Freleng was the dean of the directors, and in the forties and fifties his unit was responsible for the Tweety-Sylvester cartoons and for several of the best vehicles matching Bugs Bunny's Groucho Marx–like self-confidence against Yosemite Sam's untamed temper tantrums. Freleng had reached the height of his powers by the mid-1940s, and did not evolve significantly after that time, but neither did his work decline in quality. He continued to refine the feel for situation and the sense of comic timing that he had possessed from the start.

There was no need for anything else. He had established himself as one of the masters of the medium and continued to maintain his own high standards.

Bob McKimson's unit was the most mainstream of the three and it has been suggested that McKimson, therefore, tended to turn out the most conventional of the Warner cartoons. In some ways this is true, but he was also capable of putting his own spin on Bugs, often pitting him against such intimidating antagonists as the Tasmanian Devil. The same kind of physical humor is evident in his outings with Sylvester, such as *Pop 'im Pop* (1950). In a different vein, McKimson made a specialty of doing parodies of early television shows, the most memorable of which were takeoffs on *The Honeymooners*. Seen today, it is hard to miss the influence these diverting cartoons had on later animated television series, such as *The Flintstones*.

It was McKimson who came up with several important Warner Bros. characters, including the Tasmanian Devil as well as Foghorn Leghorn, Sylvester Junior, and Speedy Gonzales. It is also worth noting the influence he had, in his pre-directing days, as an animator and model sheet artist, creating the classic look of Bugs Bunny among others. Without McKimson, Warner's would have been a very different place.

The director who evolved the most between 1945 and the early sixties was Chuck Jones. Jones had already made some remarkable films by the end of the war but really hit his stride in the late forties when he launched Wile E. Coyote and the Road Runner on their wondrously repetitive adventures. Not everybody's cup of tea, the Coyote–Road Runner films reduced the running gag cartoon to its bare essentials, like a kid stripping a family sedan and transforming it into a hotrod. If he had done nothing else, these films would have secured Chuck Jones a major reputation in the world of animation, but these desert psychodramas represent just one aspect of Jones's mature

work. He also brought a distinctively personal touch to Bugs, Daffy, Elmer, Pepe LePew, and even that old standby Porky Pig, not to mention nonstandard characters such as Michigan J., the vaudevillian amphibian who is the star of one of Jones's several miniature masterpieces, *One Froggy Evening* (1955).

Chuck Jones had a knack for finding something new in the stock characters. His Daffy Duck manages to cling to a modicum of self-respect—buttressed by self-regard—despite being subjected to all kinds of slights and insults in cartoons like the justly famous 1955 *Duck Amuck,* which finds him subjected to the sadistic attentions of an unseen animator who refuses to provide Daffy with a stable environment.

As for Bugs, Jones permits him to be as sophisticated as Fred Astaire and as wittily self-assured as an Algonquin Round Table regular slumming at the Garden of Allah, yet as down to earth as a Dodgers fan in the bleachers at Ebbets Field. With the aid of writer Mike Maltese and art director Maurice Noble, he placed Bugs in some extraordinary situations calculated to show off these talents to best effect. Most memorably, perhaps, this trio located Bugs and Elmer Fudd in a fifties-moderne version of a mythological world for *What's Opera, Doc?,* a parody of Wagnerian melodrama that finds Bugs impersonating Brunhilde, and Elmer, as Siegfried, singing the unforgettable aria, "Kill the Wabbit."

Not surprisingly, Bugs remains the greatest favorite with collectors, with Daffy and Porky Pig also enjoying considerable popularity and the other standard characters not far behind. Cels and setups involving relatively minor characters such as Taz—the Tasmanian Devil—and Marvin Martian have proved attractive to collectors. While some animation and story drawings of Bugs Bunny and other standard characters have fetched better than respectable sums at auction, it is not uncommon to find good drawings at what may be considered bargain prices.

12

METRO-GOLDWYN-MAYER
ANIMATION

It has been reported that when Louis B. Mayer was offered the opportunity to distribute the Mickey Mouse cartoons in 1928, he declined on the grounds that the sensitive audiences attracted to Metro-Goldwyn-Mayer films would be appalled by the raucous antics of a rodent. By 1945, when Jerry the mouse (of Tom and Jerry fame) danced a duet with Gene Kelly in the feature-length musical *Anchors Aweigh*, Mayer had apparently changed his mind. (As noted in Chapter 5, the technique of combining animation with live action is almost as old as the movies.)

MGM's involvement with animation had begun a decade and a half earlier when the studio began to distribute Ub Iwerks's Flip the Frog shorts, which were produced by Pat Powers. Despite Iwerks's skill as an animator these were not a great success, lacking the sure story sense provided by a Walt Disney or a Friz Freleng. Later, soon after their departure from

Warner Bros., Hugh Harman and Rudy Ising signed a deal to produce cartoons for MGM. (Harman and Ising therefore had the distinction of being involved in the beginnings of animation at Disney, Warner, and Metro.) Starting in 1934, the Harman-Ising team began to produce a series of so-called Happy Harmonies—some featuring their Warner period characters Bosko and Honey—for MGM release.

In 1937, the studio decided against renewing its contract with Harman-Ising and instead set up an in-house production facility under the direction of an executive whose name would become as familiar to animation buffs as that of Leon Schlesinger at Warner Bros. Like Schlesinger, Fred Quimby insisted on having his name on the title cards of every cartoon produced under his auspices, so that the casual viewer might well have gained the impression that he was the sole progenitor of these films. In fact, according to those who worked with him, Quimby—despite a name that might have been thought up for a cartoon—had no knowledge of or feeling for animation, and no perceptible sense of humor. For unfathomable reasons, he was assigned as head of animation after years in the MGM sales department. At Warner Bros., Schlesinger was no favorite of the animators, but at least he left them alone as long as they remained within budget. Quimby, notwithstanding his ignorance of the medium, was given to uninformed and high-handed interference.

It is not surprising, then, to learn that the Quimby era started off with a series of flops. These were based on newspaper cartoons like *The Captain and the Kids,* which did not adapt well to the animation medium. Soon Quimby was forced to rehire Harman and Ising. In 1939, Ising came up with an amiable character in the person of Barney the Bear that was to have some mild success for the studio over the next several years. Shortly after, story artist Bill Hanna and animator Joe Barbera

were promoted from Ising's unit to become a directing team, making their debut with a cartoon called *Puss Gets the Boot,* which featured a nameless mouse and a cat called Jasper. The names would change, but the characters would remain intact. Tom and Jerry would go on to become as familiar as Bugs Bunny and Daffy Duck. With their success, MGM animation was launched into its own golden age.

In terms of those early years, collectors will find that setups and backgrounds from some cartoons of the Harman-Ising period are appealing in a picturesque, Disneyish way, their charm making up somewhat for the failure of the studio to come up with memorable characters. As noted in Chapter 10, Bosko-related animation art has a following—Bosko and Honey became more humanoid during their MGM incarnations—but for most collectors serious interest in MGM art is likely to begin with the Tom and Jerry era.

Hanna and Barbera would remain in charge of this archetypal duo for fifteen years. After both Harman and Ising had departed MGM for the second time, Hanna and Barbera were joined at the studio in 1942 by Tex Avery. From this point until the mid-1950s, Metro had two animation units that could go head-to-head with the best that Warner had to offer. Hanna and Barbera were most successful when exploiting the infinite possibilities within the framework of a classic formula—such as cat chases mouse, mouse outsmarts cat. Bill Hanna had a gift for inventing new situations and gags within this formulaic context, and Joe Barbera was an outstanding exponent of slapstick, understanding all too clearly that animated characters can be subjected to all kinds of abuse that would be unthinkable if live performers were involved. It could be argued that the Tom and Jerry cartoons were never quite as inventive as the best of the Warner productions, but they were slick (in the best sense of the word) and fast-paced—archetypal cartoon shorts,

delivering exactly what the audience expected and doing so with the perfect timing that is the key to this sort of animation.

Tex Avery was a perfect foil for Hanna and Barbera. He had a great sense of timing, too, but he was at his best when turning formulae inside out or ignoring them altogether. There was nothing he liked better than taking an old, familiar storyline such as "The Three Little Pigs" or "Red Riding Hood" and giving it some outrageous twist. In his famous *Red Hot Riding Hood* (1943), the familiar figure of the little girl on her way to Grandma's house is transformed into a voluptuous cabaret singer—a precursor of both Disney's Tinker Bell and of Jessica Rabbitt—who drives the hipster wolf wild with desire. This faintly risqué gem was followed by other vehicles starring the delectable Red (originally animated by gifted Disney veteran Preston Blair), but Avery had more characters to work with, including the sublimely imperturbable Droopy, a lugubrious basset hound who remains in understated command of the situation as the world around him goes stark raving bonkers, which it tended to do in cartoons directed by Avery. Droopy can be seen to good effect in movies such as *Droopy's Good Deed* (1951), *Three Little Pups* (1953), and *Drag-along Droopy* (1954).

Chuck Jones has pointed out that Droopy is unique in being Avery's only sympathetic character. A typical Tex Avery cartoon—and a certifiable masterpiece—is *King Size Canary* (1947), in which all the characters are either craven, sadistic, or merely nasty. The basic plot is: hungry feline seeks to dine on pet canary—precisely the formula exploited in the Tweety and Sylvester cartoons. But that's as far as the similarity went. In Avery's cartoon, the cat seeks to beef up the scrawny canary by feeding it some Jumbo Gro plant food. This works so well that the canary grows into a monstrous bird capable of devouring any normal-size cat. In self-defense, the cat drinks some Jumbo Gro himself and soon achieves gargantuan proportions. The

canary swigs down another draft of Jumbo Gro. A mouse and a bulldog get into the act. And so on, all without any redeeming moral consequences whatsoever. Aside from the Droopy vehicles, Avery's movies have nothing to do with the good guys outsmarting the bad guys, or the smart guys outwitting the dumb guys—the usual themes of cartoon shorts. Rather they place characters displaying the usual human weaknesses in a dramatic situation then explore what happens when greed, frustration, lust, and other everyday emotions take over. His classic approach can be found in the five memorable cartoons starring the utterly obnoxious Screwy Squirrel, a character who made Daffy Duck, at his daffiest, seem positively cherubic.

Except for the Red Hot Riding Hood cartoons—understandably popular with male audiences in particular—and the Droopy films, Avery's cartoons were often too extreme to enjoy the highest level of popularity with contemporary moviegoers. In recent years, however, more attention has been paid to his work as a whole and he is now generally recognized as one of the all-time masters of the American animated film. Watching a typical Tex Avery film is a continual challenge because, along with the storyline, he constantly enlivens the narrative with visual puns and graphic plays on words. (When it is said of a would-be gambler that he was "taken to the cleaners," for example, we see the unfortunate character delivered to a dry-cleaning establishment and put through the entire dry-cleaning process.) Avery was always on the lookout for new ways of telling a cartoon story and was one of the masters of the visual punchline.

As might be expected, cels, setups, and drawings of Red Hot Riding Hood have proved extremely popular with collectors; several examples have reached excellent prices at auction. Her nemesis the Wolf is another collector's favorite, and setups featuring Droopy are also in demand. As for Tom and Jerry, good-

quality animation art featuring these characters is not as easy to come by as might be imagined—certainly by comparison with contemporary material featuring the Disney standard characters. The prices achieved by Tom and Jerry cels and setups at auction are perfectly respectable, but may well be a little on the low side. As with much Warner Bros. animation art, rarity should play into the future value of MGM material.

Signed material is especially desirable. Just as Leon Schlesinger's inscribed guarantee of authenticity appears on some Warner Bros. cels and setups, so some presentation setups from MGM bear Fred Quimby's signature. Tex Avery's signature is also seen from time to time on material ranging from hand-drawn model sheets to *Red Hot Riding Hood* setups. Drawings of Red signed by Preston Blair have also been offered for sale.

TEX AVERY LEFT MGM in 1954 and was replaced by Michael Lah, formerly a member of his unit. Bill Hanna and Joe Barbera remained with the studio until it closed its animation facility in 1957, after which they moved on to achieve a new level of success as heads of their own studio (see Chapter 14.) Closing the in-house facility did not signal the end of MGM cartoons, however, and in 1961 the studio hired Gene Deitch—a Terrytoon veteran—to produce thirteen low-budget Tom and Jerry shorts, which were farmed out to animators in Czechoslovakia. These European Tom and Jerrys were watered-down imitations of the genuine article, but Tom and Jerry had a last worthy fling in 1963 when Chuck Jones—in partnership with producer Les Goldman—contracted to revive the Tom and Jerry series, this time with budgets that could guarantee respectable production values. Jones brought in some Warner Bros. veterans, including Michael Maltese and Maurice Noble, and the films that resulted displayed a shift in the eternal hostility between cat

and mouse, with situation comedy elements replacing the physical gags of Hanna and Barbera. These cartoons are interesting, but for the most part do not live up to their potential. It's almost as if F. Scott Fitzgerald had been asked to supply the final chapters of Ernest Hemingway's *A Farewell to Arms*. The skill would be there, and the respect, but the essence would be altogether different.

The late Tom and Jerrys have a definite interest for the collector since the principle characters were redesigned—Tom now had Richard Nixon eyebrows, for example, and Jerry was provided with larger, more expressive eyes. Animation art from these films has a special place both in the history of MGM and among collectors specializing in the work of Chuck Jones.

Because these late Tom and Jerrys enjoyed some success, Jones was given the opportunity to produce other animated films for MGM, the most ambitious of which was a feature titled *The Phantom Toll Booth*, a film that became entangled in the web of studio politics and received only a token release. By then, the age of major studio animation was over, the victim of changing distribution patterns and the challenge of television.

13

OTHER STUDIOS

During the classic period of theatrical cartoon shorts—from the thirties to the sixties—several other studios were involved in producing or distributing films, some of them presenting characters that are still famous and much sought after by collectors. Indeed, some of these studios aspired in their prime to be serious challengers to Warner Bros. and MGM, if not to Disney. In a couple of instances—with Fleischer and UPA—a case could be made for placing them on the same level as the Big Three. It is our opinion, however, that despite Betty Boop and Popeye the Fleischer Studio never quite sustained the impact of a top-rank producer during the sound era. As for UPA, it was responsible for some of the most innovative cartoons of its era, but its heyday was relatively brief and much of its product—perhaps because it did seem so original at the time—appears dated now.

Other companies were distinctly second-rate, though even a

studio like Terrytoons, which made no pretense at quality, was capable of coming up with characters like Mighty Mouse and Heckle and Jeckle, who live on in the folklore of the twentieth century. The animation produced by these minor studios, intended for theatrical release, is always superior to most examples of animation made directly for television.

THE FLEISCHER STUDIO/FAMOUS STUDIOS

The Fleischer Studio had its beginnings in 1915 and had been a dominant force in the industry during the silent era with its *Out of the Inkwell* series (see Chapter 5). In 1924 Max Fleischer also pioneered the "follow the bouncing ball" type of singalong film, which was extremely popular in its day.

In the sound era, starting with *Dizzy Dishes* (1930), Fleischer introduced the insouciant Betty Boop (created by Grim Natwick, the subsequent animator of Snow White), who was to achieve a good measure of success and remains a popular character with animation art collectors today. Boop is perceived as embodying the spirit of the flapper era, even though that era was over by the time she made her debut.

Three years later, the Fleischers began to produce cartoons based on characters from E. C. Segar's newspaper comic strip *Thimble Theater*, the pulp epic that gave the world Olive Oyl, Wimpy, and, of course, Popeye the Sailor Man. (Bluto was an addition to the cast devised for the movies by Segar's assistant, Bud Sagendorf.) As recognizable today as they were in the 1930s—when they rivaled Mickey Mouse in popularity—the Popeye cartoons gave birth to a trio of successful featurettes shot in two-strip technicolor. These featurettes were from fifteen to twenty minutes long, two to three times the length of the average cartoon short. Starting with *Popeye the Sailor Meets*

Sinbad the Sailor (1936), these include *Popeye Meets Ali Baba and His Forty Thieves* (1937) and *Aladdin and His Wonderful Lamp* (1939). An unusual characteristic of these featurettes—also seen in a few of the Fleischer short cartoons—was the use of three-dimensional sets instead of backgrounds. Each cel was stretched on a frame and shot in front of what was in fact a miniature stage set. This was a technique that would soon be superseded by the multiplane camera, which offered a much more satisfactory illusion of depth.

Fleischer shorts and featurettes produced animation art that is highly regarded by collectors, with early black-and-white setups sometimes fetching extremely high prices and later cels also performing well. Animation drawings and story sketches can sometimes be found at reasonable prices. Images featuring Betty Boop and the principal Popeye characters are the most sought after, but all Fleischer art has a distinctive look to it— rather old-fashioned by later Disney or Warner Bros. standards—that enhances its appeal for some people. Fleischer art is also highly valued by those interested in the medium from a historical viewpoint.

The success of the featurettes, along with pressure from Paramount, his distributor, prompted Fleischer to try his hand at animated features. (Prior to this, in 1938, the studio had moved its operations from New York City to Miami, Florida.) For his first subject, Fleischer selected Jonathan Swift's *Gulliver's Travels,* a tricky choice as it demanded convincing animation of the human form, which as Disney artists had discovered was not so easily mastered. Before they tackled *Snow White and the Seven Dwarfs,* the Disney artists had at least had the advantage of intensive training and time to hone their skills. The Fleischer artists, on the other hand, got little time to prepare for *Gulliver's Travels,* which was released in 1939, and

the consequences are quite evident in the movements and gestures of the hero and other characters. These are often awkward despite the presence of talents like Grim Natwick and Shamus Culhane on the animation team. Much of the problem seems to have derived from the necessity of relying upon inadequately trained assistants and inexperienced inkers, as well as excessive use of rotoscoping. Even if the animation had been better, however, the film would have fallen well below Disney standards because the story team, headed by Max Fleischer's brother and partner, Dave, failed to do much of interest with the potentially striking situations Swift had provided.

Gulliver's Travels did fairly well at the box office, however, and so was followed up by another Fleischer feature called *Mr. Bug Goes to Town*, released in 1941—a clumsy hybrid that is part *Mr. Deeds Goes to Town* and part *Bambi*. Not that it resembled *Bambi* in terms of ambition or skill, but the story pits nature's creatures—in the form of insects—against the destructiveness of man. As for the *Mr. Deeds* component, this is reflected in the title (which Paramount insisted on), as well as in the glib attitudes and pat ending.

The Fleischer foray into features was a failure, but meanwhile the studio was still producing shorts of above-average interest, including the remarkable Superman series, based on the Action Comics character created by Jerry Siegel and Joe Shuster. Paramount was eager to have this series succeed and allocated the kind of budgets to the project that were unheard of except at Disney. Much work was lavished on each episode—the stories and art direction were strong and the animation of the human figure was especially effective, much more so than in *Gulliver's Travels*.

Like the Betty Boop and Popeye cartoons, the Superman shorts, which are of considerable interest to collectors, demon-

strated that the Fleischer artists were at their best when pursuing their own unique goals rather than imitating the achievements at Disney or other Hollywood animation studios. In the sound era, Fleischer remained the major representative of a distinct East Coast school of animation, and within that context its best products were of high quality. The East Coast school differed from the West Coast school chiefly in its approach to the pacing and rhythm of cartoons. Disney had shown as early as 1928 that by animating to the rhythmic accents of a prerecorded soundtrack, you could achieve a bouncy feel that audiences loved. Other West Coast animators built on this discovery and eventually it led to the relentless momentum and split-second timing we associate with, for example, Tom and Jerry. The East Coast animators never completely took to this approach. Watch a Bugs Bunny cartoon, then a Popeye cartoon, and you will see that the rhythm of the two is completely different. Bugs seems more jazzy and more streamlined.

The Fleischers' inability to match the West Coast studio's sophistication in terms of rhythm and pacing may have contributed to the failure of the feature films, which plunged the studio into debt and forced Paramount to bring the Fleischer era to an end in 1942. Renamed Famous Studios—and without any involvement of the Fleischer brothers, who were by now locked in a legendary feud—the unit reopened in New York where it continued to churn out Popeye and Superman cartoons, though minus the original spark.

More inventive, during the Famous Studio era, are the cartoons starring Casper the Friendly Ghost, who made his debut in 1945 and was given his own series in 1950. Also of some note is another series, launched that same year, which starred Baby Huey (no relation to Louie or Dewey), the ugliest duckling to ever disgrace the silver screen.

In 1956, Famous Studios became Paramount Cartoon Studios. The only link to the old Fleischer Studios was the continued production of Popeye cartoons, but even this came to an end in 1957. The Paramount unit survived until 1967, mostly grinding out limited animation series for television.

WALTER LANTZ

Walter Lantz's beginnings with East Coast animation studios were discussed in Chapter 5. In 1927 he moved to California and the next year he was placed in charge of Universal's new animation unit. It initially produced cartoons featuring Oswald the Lucky Rabbit, the character that had begun life at Disney. Oswald makes an appearance in Lantz's most interesting early assignment, the animated two-strip Technicolor prologue to *The King of Jazz*, a vehicle created to highlight the musical talents of Paul Whiteman. In this prologue, a caricature of Whiteman is shown in a jungle setting, soothing the rage of a lion with his violin and encountering other adventures.

Without Disney to oversee his development, Oswald was no match for Mickey Mouse, and by 1935 when Lantz became an independent producer (though still operating under the Universal umbrella), he began looking for new characters. The first breakthrough came in 1938 when he launched the series starring Andy Panda. Shortly thereafter, Ben ("Bugs") Hardway joined the studio, coming over from Warner Bros. where he had created the primitive versions of both Bugs Bunny (who inherited his nickname) and Daffy Duck. Soon after arriving at the Lantz Studio, Hardway came up with another of his trademark obstreperous woodland creatures in the form of Woody Woodpecker, who would embark upon his career by annoying Andy Panda's father in the 1940 cartoon *Knock, Knock*. Very quickly, the hyperkinetic Woody became the

studio's top attraction, inspiring a hit song and enduring until the studio closed its doors in 1972—all this in spite of the fact that his entire character could be summed up in the single word "pest." Woody appealed to the small boy in everyone, and for many years schoolyards around the world resounded to youthful imitations of the exasperating bird's mocking laughter. (Woody's voice was created by the ubiquitous Mel Blanc, but taken over later by Walter Lantz's wife, Gracie.)

During World War II, the Lantz studio made some interesting jazz-inflected shorts in the series called Swing Symphonies; typical titles were *Juke Box Jamboree* (1942) and *Jungle Jive* (1944). Directed by Alex Lovy and Shamus Culhane, these contained racial stereotypes that would now be considered offensive, but they succeeded in matching music and animation with considerable skill. Later Lantz characters include Wally Walrus and Buzz Buzzard, but the most popular was Chilly Willy, a glum little penguin who had his moment of comedic glory during the period when Tex Avery briefly joined the Lantz team. (Willy had a good deal in common with Avery's MGM character Droopy.)

Chilly Willy and Andy Panda have their following among collectors, and some good prices have been obtained for late Oswald setups. (By that time the rabbit had taken on a naturalistic look, very different from the Ub Iwerks design with which he had started life.) Inevitably, though, it is Woody who gets the most attention, though good examples of Woodpecker art remain reasonably affordable.

PAUL TERRY'S TERRYTOONS

If the Fleischer Studio was the best of the East Coast shops from an artistic point of view, it had a commercial rival in the company Paul Terry and his partner Frank Moser set up in

Harlem in 1929. By then Terry had been in the animation business for more than a dozen years and had hundreds of cartoons under his belt (see Chapter 5). Except from the historical perspective, almost all of them were completely forgettable. This continued to be the case in the sound era when Terrytoons churned out a couple of movies a month, many of them still starring the Farmer Al Falfa character Terry had introduced at the Bray Studio back in 1916.

Terry's claim to fame was that he had been a pioneer in creating animated films by production-line methods. (He actually kept a library of standard pratfalls and the like that his animators could use again and again, thus eliminating the necessity for time wasted on animation.) And whereas his fellow pioneer Walt Disney had left plenty of room for artistry in the production line, Terry made no effort to turn out anything more than mechanically amusing strings of gags. In fairness, he was under no illusion as to what he was doing. "Disney is the Tiffany's," he has been quoted as saying, "I am the Woolworth's." Like Woolworth's, Terrytoons made money and Paul Terry managed to innovate just enough to keep audiences interested in his movies. In 1938 he introduced a character called Gandy Goose, who was little more than a caricature of the film and radio comedian Ed Wynn. Four years later, he launched Mighty Mouse, the most successful of the studio's stars. The idea for a takeoff on Superman seems to have been suggested by animator Izzy Klein, whose candidate for the parody was a fly with superhero strength. Terry—wisely it would seem—accepted the basic idea but preferred a mouse as his avatar of infallibility.

Introduced in 1946, Heckle and Jeckle were a pair of ruffian magpies, one an obvious New Yorker, the other affecting a stage version of a British accent. Not dissimilar to Woody

Woodpecker in demeanor, they at least displayed a certain amount of verbal wit in playing off one another. Another Terrytoon teaming of the postwar period was Percy the cat and Roquefort the mouse, whose 1950 debut appeared to be a response to the success of MGM's Tom and Jerry.

In 1955, Terry sold the studio to CBS, which continued to produce Terrytoons, both for television and for theatrical release. In this final form, the studio survived until 1968, producing some pioneering series and providing a springboard for talents as diverse as Ralph Bakshi and Jules Feiffer.

UPA

Terrytoons of the CBS era leaned heavily on the graphic style developed by a far more interesting studio, UPA—United Productions of America, to give it its rarely used full name—which during its sixteen-year existence from 1943 to 1959 turned out a handful of cartoon classics and did much to change the look and options of American animation.

The dominant graphic style for animation in the early forties was that which had been forged at the Disney studios—in effect, a brilliant adaptation of the norms of nineteenth-century academic art. Concessions to modernism were virtually zero, except, to take one example, for the Bach Toccata and Fugue section of *Fantasia,* which was inspired by the abstract animation of German emigré Oskar Fischinger (who worked on the film without accepting credit).

Many of the younger artists at Disney were eager to experiment with other more contemporary approaches and a number of these were among the animators who left Disney after a 1941 strike that divided the entire animation industry in Hollywood. These included Zachary Schwartz, David Hilberman, and

Stephen Bosustow. In 1943, Schwartz, Hilberman, and Bosustow came together to form the Industrial Film and Poster Service and the following year they were hired by the United Auto Workers to produce an animated film supporting Franklin Delano Roosevelt in his presidential campaign against Thomas E. Dewey. Directed by Chuck Jones, moonlighting from Warner, *Hell-Bent for Election* portrayed Roosevelt and Dewey as rival trains—FDR being the streamliner and Dewey "The Defeatist Limited." The film attracted a good deal of attention and in 1945 Industrial Film and Poster Service became United Productions of America. Just a few months later, Schwartz and Hilberman sold their shares in the company to Bosustow and he gradually built the company to the point where, in 1948, Columbia Pictures offered UPA the opportunity to produce theatrical shorts.

Bosustow's great contribution to animation lay in his ability to surround himself with highly gifted individuals and to give them the freedom to create without managerial interference. One of the first people he hired was John Hubley, a leading figure in postwar animation, who was soon appointed vice president of creative affairs and, as a director, began to breathe new life into the Fox and Crow series that had been inaugurated at Columbia by Frank Tashlin during his brief tenure. Many first-rate talents worked at UPA over the next decade, ranging from Disney veterans like Art Babbitt to ex-Warner Bros. artists like Robert "Bobe" Cannon. It was Cannon who directed *Gerald McBoing-Boing* (1951), a film that did a great deal to boost the studio's reputation. The story came from a poem by Theodor Geisel, better known as Dr. Seuss, and the graphic approach employed by Cannon and designer Bill Hurtz emphasized linear invention of a kind that was new to commercial animation. Without actually imitating fine artists like Picasso and Klee,

Cannon and Hurtz borrowed from their approaches to establish an animation context in which lines could be set free and allowed to create characters and situations, rather than simply describing them.

Cannon directed many of UPA's finest films, including the memorable *Madeline* (1952), based on the beloved Ludwig Bemelmans book, and Hurtz went on to make a classic version of James Thurber's *The Unicorn in the Garden*.

But the most dynamic force at UPA was John Hubley, who in 1949 directed a cartoon called *Ragtime Bear,* which introduced the studio's most reliable star, Mr. Magoo. Irascible, severely myopic, and totally self-absorbed, Magoo would bumble his way through more than forty theatrical cartoons over the next decade, proving himself to be a reliable source of revenue. Only three of these cartoons were directed by Hubley, however, most of them were supervised by Pete Burness. This was because Hubley's restless imagination made him impatient with situations in which he was forced to repeat himself. Instead, he went on to direct one-shot cartoons like *Rooty-Toot-Toot* (1952) and special assignments such as the seven animated sequences used in Stanley Kramer's live-action feature *The Fourposter* (1952).

Like Cannon, Hubley, a brilliant draftsman, was a master of what has become known as the UPA style, though in reality the art direction of the studio's productions (with the exception of the Magoo cartoons) varied considerably from film to film. What all the UPA movies do have in common visually is an attempt to adapt the lessons of twentieth-century art and graphic design to the animation medium. Sometimes the results were reminiscent of the paintings of Raoul Dufy, at other times of the drawings of Saul Steinberg.

Although the best UPA cartoons were both innovative and

distinguished, by the late fifties the studio was in trouble. A poorly conceived feature, *Arabian Nights*—starring Abdul Azziz Magoo and released in 1959—did nothing to alleviate this situation, and in 1960 Bosustow sold the studio, which survived for a while, but in name only. Thus, one of the more interesting experiments in the history of animation came to an end. UPA's achievement gives it a secure place in the history of American animation; its innovative graphics make for striking animation art; and its characters, especially Magoo, are authentic popular culture icons. At their best, UPA cartoons are among the aristocrats of animated shorts. Unfortunately for collectors, relatively little art from this studio has found its way to the market to date.

OTHER STUDIOS

There were still other studios that contributed, to a far lesser extent, to the golden age of theatrical cartoon shorts. Passing reference has been made to the Iwerks Studio, which had an independent existence from 1931 to 1936, producing movies featuring Flip the Frog and, from 1933, Willie Whopper, as well as a Silly Symphony–type series called Comicolor Cartoons. None of these films were very successful but Ub Iwerks will always be remembered for his enormous contribution—second only to Walt Disney's—in establishing the reputation of Disney's animation, and also for his later technological innovations. (Iwerks did much to develop the multiplane camera, and to introduce a variety of special effects techniques for both live action and animation.)

A minor producer of some historical interest was the New York–based Van Beuren studio, which made cartoons for distribution by RKO. In the silent era, Amedee Van Beuren had

employed Paul Terry to produce shorts purportedly based on Aesop's Fables. In the early thirties, Van Beuren animators came up with mouse characters that were so close in appearance to Mickey and Minnie that Disney sued—and won. Next, Van Beuren came up with Tom and Jerry. Not *the* Tom and Jerry, but a pair of tramplike humans who predated MGM's cat and mouse by several years. Later, the studio turned out movies based on *The Little King* comic strip and the *Amos 'n' Andy* radio show. By the time Van Beuren began to produce *Felix the Cat* cartoons and another series based on Fontaine Fox's *Toonerville Trolley*, the quality of his films was quite respectable.

Then, in 1936, the rug was pulled out from under Van Beuren. Disney left United Artists and signed a distribution deal with RKO. With Disney in their camp, RKO had no need for any other cartoons and the Van Beuren operation folded.

The Charles Mintz studio started in New York where, from 1925, it produced films starring George Herriman's famous Krazy Kat (films that failed to capture the magic of the original). In 1930, at the beginning of the sound era, Mintz moved his base to California where the studio had some mild success with a small boy character known as Scrappy and the mandatory series of Silly Symphony imitations, known in this case as Color Rhapsodies. In 1939, the Mintz studio was taken over by Columbia and became Columbia Screen Gems, which survived until 1949 when it was made redundant by Columbia's commitment to UPA.

From a collecting point of view, the work of these minor studios is likely to appeal only to those who have a serious interest in the history of animation. Individual examples of work from Screen Gems or Van Buren can be extremely attractive and should not be overlooked. The fact that they lack the mass

appeal of animation art from Disney or Warner Bros. means that they will often be affordably priced. Scrappy and Flip the Frog may lack the cachet of Pluto or Daffy Duck, but they are significant parts of the history of animation and as such they each have their own unique value.

14

TV Animation

The two most significant commercial developments in the animation world since the demise of the theatrical cartoon were the rise of animation for television and the revival of the animated feature. The first to take hold was television animation, which evolved rapidly in the fifties, just as the call for theatrical cartoons was beginning to wane, and which has thrived ever since, especially in terms of shows aimed exclusively at children. The demand for cartoons on the part of networks, independent stations, and cable channels has provided work for a multitude of talented animation artists. Unfortunately the standards of the shows seldom come close to challenging those of the classic shorts created for the big screen. These, of course, have enjoyed a second life on television which has made them familiar to several generations of children and adults.

Actually television animation got off to a good start when *Crusader Rabbit* made its debut on NBC in 1949. Developed by

Jay Ward and Alexander Anderson Jr., this was the first cartoon show created specifically for the new medium. Produced at first in black and white, it featured Crusader and his tiger sidekick Rags, who were pitted against a variety of wacky villains. The writing was often very clever—full of kitschy puns and inside jokes—which helped to compensate for the primitive limited animation.

The term "limited animation" has become familiar even to the general public. It refers to a kind of animation in which there are fewer in-between phases between key poses, in which only parts of a given image may be animated at a given time, and in which stock movements, such as walks, may be repeated again and again from a reusable basic animation library. In short, it describes a kind of animation where every imaginable corner is cut for the sake of economy. Inevitably it is crude and repetitive, though it can be used effectively when, for instance, the method matches the styling, as in the Peanuts specials, based on the Charles Schultz characters and produced by Bill Melendez and Lee Mendelson.

Limited animation was not invented for television—even Disney used it for special purposes, such as World War II training movies—but it was inevitable that it would become the staple of TV animation because television animators had to churn out enormous quantities of footage and keep costs at a minimum. The footage needed to make up enough episodes for one 30-minute Saturday series for a single season is equivalent to that required for four or five full-length features. Clearly, this does not allow for Pinocchio-level character animation.

Typically, the most successful television cartoons have been the ones with the best writing, the scripts compensating for deficiencies in visualization. This is certainly the case with *Rocky and His Friends,* which made its debut on ABC in 1959. Produced by Jay Ward, this show was a spin-off of *Crusader*

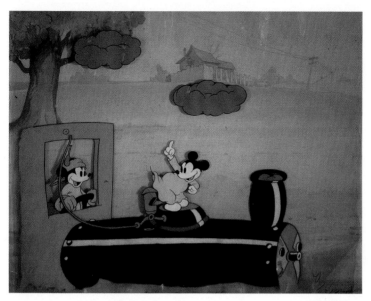

A rare black-and-white multicel setup showing Mickey's nephews, Ferdy and Morty, from the Disney short Mickey's Steam-Roller, *1934 (© Disney).*

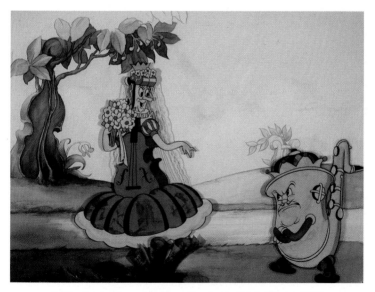

A fine production setup from the classic Walt Disney 1935 Silly Symphony, Music Land *(© Disney).*

Mickey Mouse and Donald Duck in a cel from Alpine Climbers, *a 1936 short, which has been applied to a veneer background. This is an example of how production cels were sometimes mounted for presentation purposes with decorative non-production backgrounds (© Disney).*

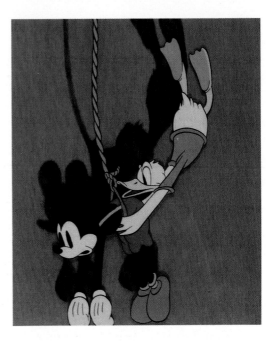

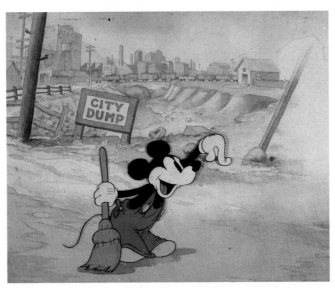

This Mickey Mouse cel from Clock Cleaners, *1937, has been combined with a production background from* Mickey's Trailer, *1938. Although the elements are taken from two different films, this is still a valuable setup because of the rarity of the material (© Disney).*

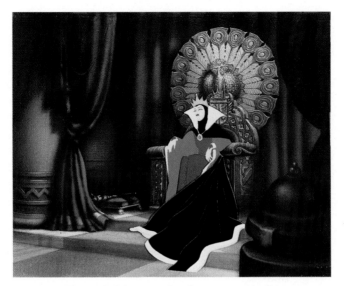

The wicked Queen on her throne, a spectacular
multicel setup from Disney's pioneering feature,
Snow White and the Seven Dwarfs, *1937 (© Disney).*

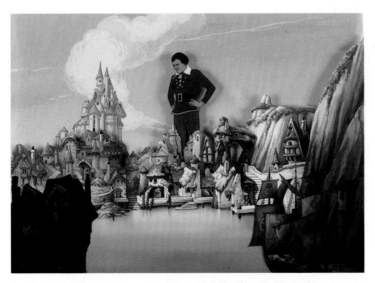

In this setup from Max Fleischer's Gulliver's Travels,
1939, the hero towers over the town of Lilliput.

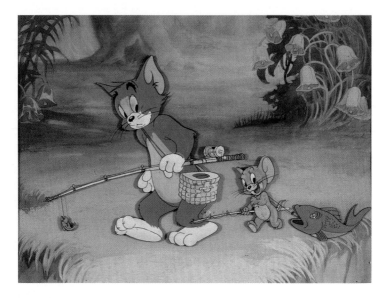

This 1940s MGM setup shows Tom and Jerry in one of their rare noncombative moments (™ & © Turner Entertainment Co.).

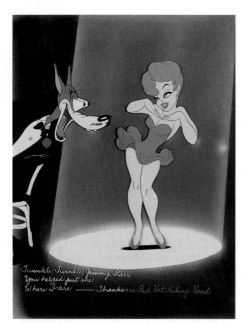

When Tex Avery worked for MGM in the 1940s, he prepared this presentation cel setup of Red Hot Riding Hood for Hollywood columnist Jimmy Starr (™ & © Turner Entertainment Co.).

A beautifully rendered panoramic watercolor production background of Geppetto's studio from Disney's Pinocchio, *1940 (© Disney).*

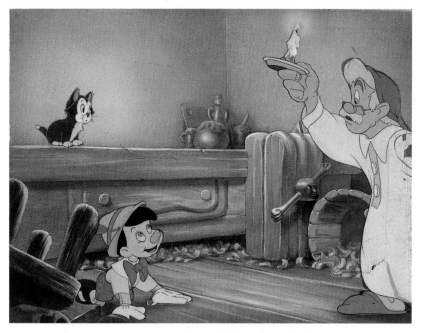

A key production setup from Disney's Pinocchio, *1940 (© Disney).*

This setup from Disney's Fantasia, *1940, is one of many sold by the San Francisco–based Courvoisier Gallery, whose label is on the back (© Disney).*

Morpheus, the god of sleep, a concept sketch for the Pastoral Symphony *sequence of Disney's* Fantasia, *1940 (© Disney).*

A pan production setup combining images from two 1941 Disney shorts, The Little Whirlwind *and* The Nifty Nineties *(© Disney).*

This cel of Woody Woodpecker, taken from the main title sequence in which he pecks out his name, has been combined with a non-production background and signed by producer Walter Lantz (© 1940 by Universal City Studios, Inc. Courtesy of Universal Studios Publishing Rights, a division of Universal Studios Licensing, Inc. All Rights Reserved).

This 1944 cel of the first Warner Bros. cartoon star, Porky Pig, is enhanced in value by the fact that it is signed by Leon Schlesinger, head of Warner Bros. animation unit from 1930 to 1944 (© Warner Bros.).

In this Warner Bros. cel setup, Pepe Le Pew rises from a barrel of fermenting grapes (© Warner Bros.).

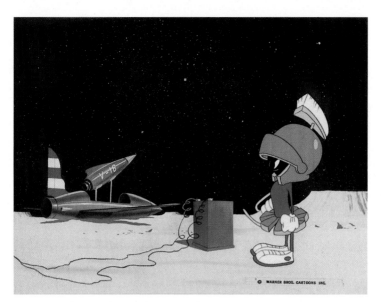

A rare cel setup depicting Marvin Martian against a production background painted for Hare Devil Hare, *a 1948 Warner Bros. short (© Warner Bros.).*

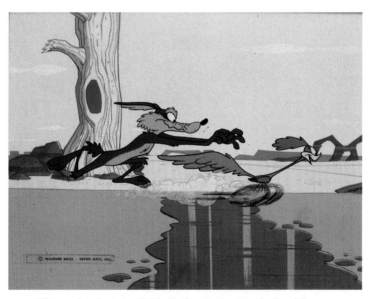

This undated setup of Wile E. Coyote chasing the Road Runner was probably used for publicity purposes (© Warner Bros.).

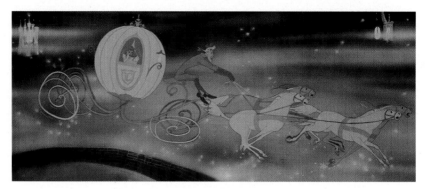

An elaborate cel setup from Walt Disney's Cinderella, *1950 (© Disney).*

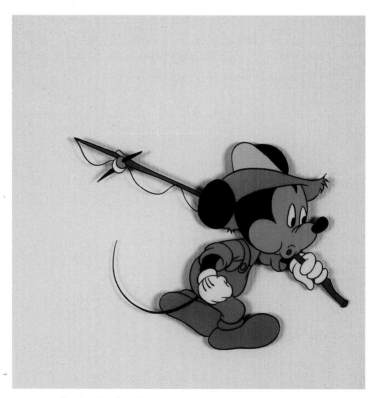

*A cel of Mickey Mouse dressed for fishing, from an early
Walt Disney television production, c. 1950 (© Disney).*

This fine key setup from Disney's Peter Pan, *1953, depicts Captain Hook, Mr. Smee, and the weeping Tinker Bell in the captain's cabin (© Disney).*

An unusual large (28½″ by 10½″) vertical pan setup from Disney's Peter Pan, *1953 (© Disney).*

Outstanding background art contributes to the quality of this production setup from the finale of Lady and the Tramp, *1955 (© Disney).*

Briar Rose in the forest, an unusually fine panoramic production setup from Disney's Sleeping Beauty, *1959 (© Disney).*

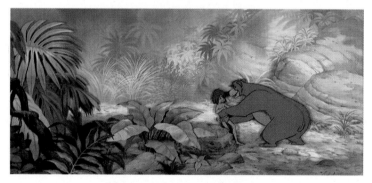

A pan production setup depicting Baloo and Mowgli from Disney's The Jungle Book, *1967 (© Disney).*

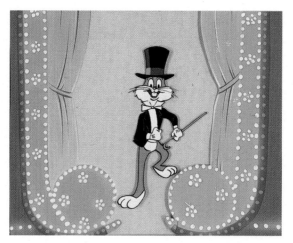

Bugs Bunny in a cel from the Bugs Bunny and Road Runner *television show, c. 1981 (© Warner Bros.).*

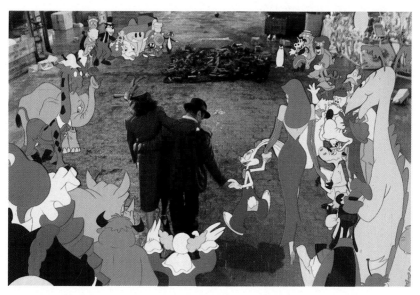

An elaborate setup from Touchstone Pictures–Amblin Entertainment's Who Framed Roger Rabbit, *1988, this image, incorporating characters from different periods and different studios, shows how cel animation can be successfully combined with live-action footage (© Disney/Amblin Entertainment Inc.).*

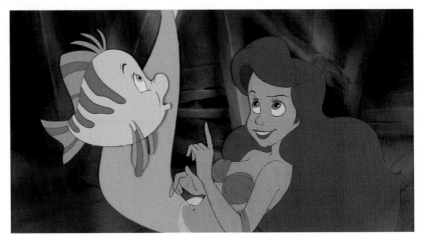

A two-cel setup depicting Flounder and Ariel, the latter one of the most popular of recent Disney characters, from The Little Mermaid, *1989 (© Disney).*

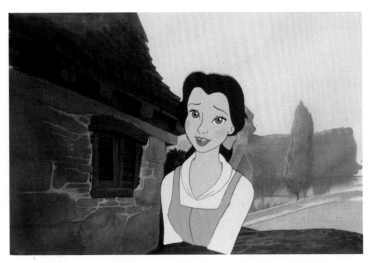

A cel setup showing Belle, the popular heroine of Disney's Beauty and the Beast, *1991, seen full face, a pose much desired by collectors (© Disney).*

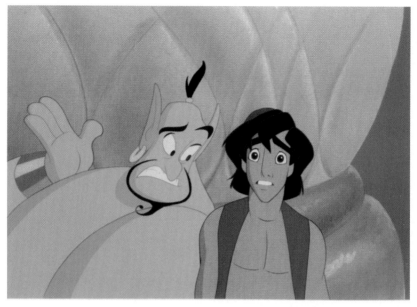

Aladdin and Genie, a powerful cel setup from
Disney's Aladdin, *1992 (© Disney).*

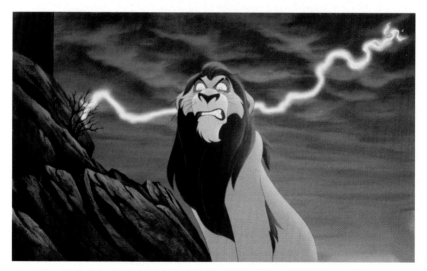

In this dramatic setup from The Lion King, *1994, Scar's*
malicious sneer is highlighted by a bolt of lightning (© Disney).

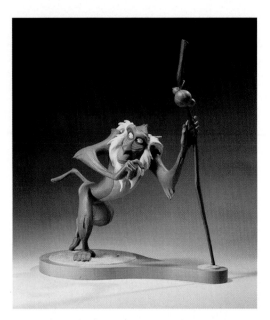

This full-figure maquette of Rafiki was used by animators as an aid to visualization during the making of Disney's The Lion King, *1994 (© Disney).*

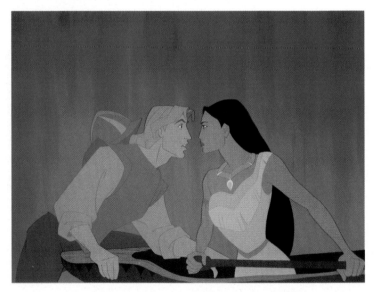

This cel setup from Disney's Pocahontas, *1995, demonstrates how characters seen in profile can make for powerful and expressive imagery (© Disney).*

Rabbit featuring Rocky the Squirrel, Bullwinkle the Moose, and an assortment of other colorful characters who were put into outrageous situations—often with strong satirical potential—by a team of first-rate comedy writers. Clever scripts were also the key to the success of *Beany and Cecil,* another hit of the early sixties, created by former Warner Bros. ace Bob Clampett. All material associated with shows produced by Jay Ward and Bob Clampett is collectible.

By 1960, the television animation market was coming under the domination of two other major studio veterans, Bill Hanna and Joe Barbera, who having left MGM and Tom and Jerry behind them formed their own company, which was soon turning out a whole range of successful shows for television. First came *Ruff and Ready* (1957), followed by *The Huckleberry Hound Show* (1958), then *The Flintstones* (1960), *Yogi Bear* (1961), *The Jetsons* (1962), and *Johnny Quest* (1964). This is only a partial listing of the team's television series, but it gives some idea of their prominence in the field of TV animation.

It should be noted that *The Flintstones* was the first animated series ever to be seen in prime time on network television, becoming a staple of ABC's Friday night lineup for several seasons. Obviously patterned after Jackie Gleason's live-action *The Honeymooners,* the show was nonetheless original to the extent that it was able to find novel humor in the fact that the Flintstone family and their neighbors, the Rubbles, were essentially modern suburbanites living in the Stone Age. Still popular in reruns today, the show was a huge success because of imaginative scripts, many of them written by Warren Foster, formerly a top writer in the Warner animation department where he helped shape the personalities of Bugs Bunny and other Looney Tunes characters.

It would be misleading to suggest that the market for animation art from these shows in any way compares with the

market for animation art from theatrical shorts and features. Still, these early television characters can claim a substantial niche in the pantheon of American popular culture. Everyone is familiar with Bullwinkle, Yogi Bear, and Fred Flintstone. They and their co-stars are genuine pop icons and as such are collectible, whether adorning lunch pails or cel setups.

For the most part, the scores of kid-oriented animated shows that dominated Saturday morning TV from the mid-sixties on are eminently forgettable, although no doubt there are collectors out there somewhere hoarding everything connected with *Space Kidettes* or *Frankenstein Jr. and the Impossibles*. Shows featuring prepubescent private investigators and their oversized pets were sandwiched between animated afterthoughts based on live action hits such as *I Dream of Jeannie* and *The Addams Family*. Critics habitually referred to Saturday morning TV as "a desert" or "a wasteland." Whichever term you chose, almost all the animation to be found in this time period was entirely forgettable.

By the sixties, Hanna-Barbera had been joined by other mass production studios such as DePatie-Freleng, Ruby-Spears, and Filmation. Amid the dross, each managed to come up with the occasional worthwhile effort. DePatie-Freleng was responsible for the above-average *The Pink Panther* series, which had its origins in theatrical shorts that were themselves based on the character Friz Freleng had designed for the title sequence of Blake Edwards's feature, *The Pink Panther*. Animation art from the *Pink Panther* shows provides an example of television material that is considered collectible. Filmation produced a very popular series—its name was modified several times—based on the *Archie* comic books created by Bob Montana. The same studio enjoyed perhaps its finest moment with the long-running *Fat Albert and the Cosby Kids*, based on characters created by Bill Cosby in his stand-up routines—a series that

brought to life a group of black kids with a warmth and realism that is rare in any kind of television show.

Fat Albert is an instance of a television program that might well have long-term appeal to collectors. Bill Cosby is enough of an icon to make the series viable from a collectible point of view, but beyond that the show was exceptionally well drawn, with characters like Weird Harold, Mush Mouth, and the Brown Hornet being realized with some subtlety, which is evident in cels and other animation art. Some of the establishing backgrounds were as deliberately detailed as if intended for a theatrical feature.

Jay Ward had one final memorable outing with *George of the Jungle,* which was first seen on ABC in 1967. Like *Crusader Rabbit* and *Rocky and His Friends,* this series displayed a hip sense of humor that blended easily with satire and parody. George himself was an inept Tarzan wannabe. The best segments of the show, however, were built around Henry Cabot Henhouse III, who, after a shot of Super Sauce, became the almost but not quite superhero Superchicken, inclined to find himself entangled with nefarious types like the warped wizard Merlin Brando from the Isle of Lucy. But although the puns came thick and fast, this clever show never really caught on and lasted just one season.

A very different kind of series, and one that was extremely popular for two or three seasons, was Hanna-Barbera's *The Smurfs,* which made its debut in 1981. Based on a Belgian comic strip that had long been popular in Europe, the animated Smurfs were charming, elflike innocents drawn with a kind of stylized simplicity reminiscent of the early days of Mickey Mouse. The folksy atmosphere of these shows was rather refreshing within the slick context of American television. Smurf animation art is an example of television material with strong crossover appeal because other Smurf products—soft

toys and figurines, for example—are highly sought after by collectors.

In 1985, Disney entered the TV animation field with shows such as *The Wuzzles* and *Gummi Bears,* which made a significant attempt to bring higher standards of animation to the small screen. Until then, Disney had shunned the field of television animation precisely because the medium's economics would not support its traditional high level of production values. Now it was felt there was enough profit in television animation to permit reasonable production values, and the first two Disney series bore out this theory. Subsequent Disney shows include the witty *Darkwing Duck* and the dramatic *Gargoyles.* Disney even permitted standard characters to be revamped for television in shows like *DuckTales* (based on the Carl Barks comic books starring Scrooge McDuck et al.), *Chip 'n' Dale: Rescue Rangers,* and *Goof Troop.* All these shows have performed well—very well in the case of *DuckTales* and *Goof Troop,* which led to theatrical spin-offs, *Ducktails: The Movie* (1990) and *A Goofy Movie* (1995).

Art from *Gargoyles* has been offered at auction where it performed reasonably well. In addition, TV art is being sold directly through the Walt Disney Company.

If comic fare has been one staple of TV animation, the other has been action series such as *G.I. Joe, Transformers, Thundercats,* and Filmation's immensely successful *He-Man and the Masters of the Universe.* None are animation masterpieces by any stretch of the imagination, but they are of some interest to collectors because they were either based on existing action figures or spawned highly collectible merchandise. Interestingly, cels and drawings from these shows are often quite striking—like covers of comic books—even when the animation they contribute to is decidedly third-rate on screen.

• • •

IF RELATIVELY FEW animated television series have inspired collector enthusiasm, animated specials for television have a better track record. Much of the credit for this should go to Bill Melendez and Lee Mendelson, who in 1965 produced *A Charlie Brown Christmas*—a 30-minute show that would become a holiday season staple and the first of more than a score of specials featuring the Charles Schulz "Peanuts" gang. In shows like *It's the Great Pumpkin, Charlie Brown,* and *Charlie Brown's All-Stars,* Melendez and Mendelson managed to translate Schulz's childlike cartoon style into animation art that perfectly captures the spirit of the original. Top-quality cel setups from these shows have sold at auction for prices that are extraordinary, even by feature film standards, at least one having changed hands for well in excess of $30,000. In large part this is due to the fact that the Peanuts characters—whether in the Sunday comics section or on TV—have become archetypes. Like Donald Duck and Bugs Bunny, Charlie Brown, Lucy, Snoopy, Schroeder, Linus, and Peppermint Patty are known around the world.

The same is true of many of the characters imagined by Theodor Geisel, who as Dr. Seuss gave us *How the Grinch Stole Christmas, Horton Hears a Who,* and *The Cat in the Hat,* among many other memorable books marked by risibly predictable rhymes and uniquely wry drawings. The three titles mentioned were turned into television specials by Chuck Jones, who successfully captured the look and spirit of the originals. Since both Seuss and Jones are highly regarded figures, the animation art from these specials is highly collectible.

An outstanding one-shot show was *A Doonesbury Special* (1973), based on Garry Trudeau's acerbic comic strip and brought to the screen by John and Faith Hubley. The animation was particularly accomplished, retaining the feel of the

Trudeau original while emphasizing the characters' personalities through the use of body language. Sadly, this was to be John Hubley's last film: he died suddenly during production.

A different kind of special was Richard Williams's adaptation of Charles Dickens's *A Christmas Carol* (1973)—a visual tour de force in which the animators brought to life the cross-hatched look of nineteenth-century illustrations. Except for his work on *Who Framed Roger Rabbit*, Williams has been unjustly overlooked by collectors. Given his high standing among today's animators and animation historians, it is safe to assume that this oversight will be rectified at some point in the future.

THE RECENT PAST has not been a banner period for animated television specials. It has seen, however, the appearance of some extremely imaginative television series, including *The Simpsons, The Ren & Stimpy Show, Beavis and Butt-head,* and the wildly inventive *Duckman.*

The Simpsons, based on characters developed by Matt Groening, a staple of the Fox Television Network since 1990, is probably the most successful animated television series ever. For its first three years, the five members of the Simpson family guested on Fox's *The Tracey Ullman Show.* Cel setups from *The Simpsons* have already sold for in excess of $10,000 and it is likely that they will become even more highly regarded, both for strong graphic content and for historical value.

Nickelodeon's *The Ren & Stimpy Show* is the epitome of deliberate bad taste and as crazed in its way as the wildest of the Warner Bros.' cartoons in the days of Bob Clampett and Frank Tashlin. These characters are likely to become sought after too, especially examples from the pre-September 1992 shows directed by John Kricfalusi, who was fired by the network, nominally for delivering shows late but reputedly for

refusing to water down his extreme tastelessness. Almost as tasteless is MTV's *Beavis and Butt-head*. This show is an example of limited animation at its worst, but that does not matter in the least because the bad animation is a match for the intended stupidity of the principal characters. Although devoid of artistic or philosophical interest, *Beavis and Butt-head* has given us characters as relevant to our times as Donald Duck or Popeye were to theirs. Like *The Simpsons* and *Ren & Stimpy*, *Beavis and Butt-head* has joined the popular culture pantheon, which assures the collectibility of its characters.

Paramount Television's *Duckman*, produced by Klasky-Csupo, is less well known to the general public but has a strong cult following. Based on an underground comic created by Everett Peck, this is the continuing tale of a "hard-boiled duck" on America's mean streets, where anything can happen and generally does. Cast with marvelous voice talent (Jason Alexander, Dweezil Zappa, Tim Curry) and brought to the screen with tremendous visual flair, *Duckman* is proof that television can provide a home for animation of the highest quality.

Even so, watching animation on a television screen is quite different from watching it in a darkened movie theater, sharing the emotions or laughter with hundreds of other people in the surrounding darkness. It was that shared special theater experience that contributed to making Bugs Bunny, Donald Duck, Mr. Magoo, and Tom and Jerry so memorable.

Even extremely successful television shows are often forgotten almost as soon as they vanish from the airwaves. The lack of a shared theatrical experience may help explain this, though in some cases it almost seems as if the producers want the show to be forgotten. For a few years, *Teenage Mutant Ninja Turtles* was one of the most popular of all animated shows with kids. Then it crossed over into the live-action field in the form

of successful theatrical features. Logically, there should have been a respectable market for Ninja Turtle animation art. And this might conceivably have developed if the producers had not decided to dispose of their cels at Toys 'R' Us for prices as low as five dollars.

TV animation can only have value if the men and women who produce it ascribe value to it. It is in this area that shows like *The Simpsons* and *Duckman* have set a valuable example.

15

RECENT FEATURES

For almost thirty years, starting in the early 1940s, Disney was virtually unchallenged in the field of feature animation. Rare efforts at full-length movies by others, such as Chuck Jones's *The Phantom Tollboth,* vanished almost without trace. Then, in 1968, came the British feature *Yellow Submarine,* which caught the imagination of the public and enjoyed a considerable financial success.

Styled by Heinz Edelmann and directed by George Dunning, *Yellow Submarine* employed songs by the Beatles to bolster a narrative in which the Fab Four were pitted against the fun-hating Blue Meanies. In retrospect, the plot is flimsy, the animation is uninspired, and the Peter Max–style, quasi-psychedelic art direction seems dated, but the film as a whole does continue to display a freshness that came from a willingness to mix visual idioms. And, of course, there were those

timeless songs. Whatever its shortcomings, *Yellow Submarine* has an important place in the history of the animation revival. Artwork from the film is sought after by Beatles collectors as well as animation buffs.

Despite its success, *Yellow Submarine* had no immediate progeny. Ironically, as has been pointed out by several commentators, the chief beneficiary of *Yellow Submarine's* success was Disney. Happy that it implied a new and receptive audience for its own "psychedelic" masterpiece *Fantasia,* the studio put it into re-release to great acclaim.

Fritz the Cat (1972) was another kind of animated feature from another front of the rock 'n' roll revolution. Produced by Steve Krantz and written and directed by Terrytoons veteran Ralph Bakshi, it was based on stories created by the great underground cartoonist Robert Crumb. *Fritz the Cat* presented the misadventures of a would-be hipster feline in pursuit of sex, drugs, racial enlightenment, and more sex.

Crumb is on record as despising Bakshi's version of his characters, dismissing the movie as a Hollywood travesty. In fact, this is a somewhat harsh judgment. Certainly the animated Fritz lacks the unadulterated bile of Crumb's vision, and the animation cannot fully capture the surgical precision and descriptive exactitude of his line. That admitted, however, the Bakshi film was hardly a typical Hollywood product. Decidedly adventurous by the standards of the period, it was well executed and demonstrated that there was a market for animated films aimed at adults rather than children. If we did not have the Crumb prototype to measure it against, *Fritz the Cat* would probably be judged a major success. Even so, *Fritz the Cat* remains an important landmark and animation art from the production is prized for exemplifying the concerns of the period.

This is true too of Bakshi's *Heavy Traffic,* released in 1973.

Reportedly a somewhat autobiographical film, this is the animated tale of a character called Michael who tries to escape the world typified by his hostile and bickering parents by exploring the underbelly of New York City. Like *Fritz the Cat, Heavy Traffic* did well at the box office and its success enabled Bakshi to produce a movie about Harlem life released in 1975 as *Coonskin.* (In video, it is known as *Streetfight.*) Intended as a sympathetic, if bleakly pessimistic, portrayal of African Americans, *Coonskin* was perceived by many as racist.

At this point Bakshi changed direction and began to produce fantasy films including *Wizards* (1977) and *The Lord of the Rings* (1978). These relied heavily on rotoscoping—the technique in which characters are shot in live action then traced onto animation paper. This system was first used by the Fleischer brothers before 1920 (see Chapter 5). It had been tried and rejected many times after that and Bakshi's reliance on rotoscoping led to movies that were unsatisfying. They were stilted as animation and decidedly inferior to his first three features. This should not detract from the significance of his first three films, however, as they continue to offer an alternate path for animation to follow.

Other animated features of the seventies and eighties ranged from Bruno Bozetto's *Allegro Non Troppo* (1977), an amusing parody of *Fantasia,* to weak compilations of old Warner Bros. shorts, such as *1001 Rabbit Tales* (1982). A major disappointment was Richard Williams's *Raggedy Ann and Raggedy Andy—A Musical Adventure.* This high-budget film was a textbook illustration of how impossible it is to make a satisfying animated feature without an engaging and effective storyline. Williams's ability to create strong visuals is intermittently evident in this film, which also employed the talents of all-time greats like Grim Natwick, Art Babbitt, and Eric Goldberg, but the narrative drive was missing and the movie flopped.

A much better film was *Watership Down* (1978), based on Richard Adams's bestseller about a tribe of rabbits seeking a new home. If this sounds like a typical Disney plot, it was not at all a Disney style of movie; it was stark and uncompromising in its realism. Produced and directed by Martin Rosen, this is among the most underrated of animated features.

Among the more interesting developments of the eighties was the challenge to Disney's monopoly in the area of family-oriented animated films by a group of former Disney artists headed by Don Bluth. Bluth's first feature was *The Secret of NIMH* (1982), a film that turned out to be an exercise in animation nostalgia, deriving much of its visual style from the early Disney features. The same has been more or less true of all of Bluth's subsequent features to date, though none has displayed Disney's sure sense of plot and drama.

The second Bluth movie, produced by Steven Spielberg, was *An American Tale*, the story of Fievel Mousekewitz and his family who flee intolerance and pogroms in the Old Country to find a better life in the New World. A parable representing the flight of Jews from Eastern Europe at the turn of the century, the film is extremely well animated but suffers from narrative oversimplification that ultimately reduces a major historical phenomenon to a Tom and Jerry war between cats and mice. Although not a total failure, the film did only modest business.

Next came Bluth's *The Land Before Time* (1988), a story about dinosaurs that is a shameless tearjerker, but nonetheless worthy of note in terms of animation technique. The title of *All Dogs Go To Heaven* tells all one needs to know about the storyline of Bluth's fourth feature, released in 1989. Despite Bluth's overdependence on cuteness and sentimentality, he has demonstrated more consistently than anyone else to date that top-quality character animation can exist outside the Disney orbit. Production art from Bluth's films is often attractive and

some pieces were offered at auction in 1991, most of them selling for relatively modest prices.

The enormous box-office success of Disney films like *Aladdin* and *The Lion King* has meant that more and more studios have been scrambling to enter the feature animation arena. Warner Bros., Twentieth Century Fox, and newcomer Dreamworks have all announced ambitious programs. They will not find any bed of roses. Disney's most recent films, though still hits by normal standards, have been notably less successful than those of the early nineties. The size of the animation audience has been called into question, as has its makeup.

The classic Disney animated feature is a film that parents will take their children to then end up enjoying themselves. Like traditional fairy tales, they give children a taste of the adult world and remind adults what it was like to be a child. This was true of *Snow White and the Seven Dwarfs* and *Lady and the Tramp.* More recently, it was equally true of *The Little Mermaid* and *The Lion King.* Films like *Pocahontas* and *The Hunchback of Notre Dame,* however, seem slanted toward adults, and many industry analysts feel this has hurt at the box office. The man who instigated both of those movies, Jeffrey Katzenberg, now has his own studio, Dreamworks, with its own feature animation department that seems set on producing films that challenge the viewer intellectually.

Why should there not be animated movies that appeal primarily to an adult audience? The medium is well enough established, surely. And producers like Ralph Bakshi and Martin Rosen have demonstrated that there are other paths to follow. Perhaps the problem with the recent Disney films is that they have compromised too much, wanting to appeal to adults but also courting their kiddie constituents.

Then there is the most basic question of all: How many animated features a year can find an audience? One? Two? More?

Feature animation is entering a fascinating and critical period. All that can be said for certain is that there is an enormous pool of talent available and a considerable audience waiting to see what it can offer. We could be on the threshold of a great era for the medium and for collectors of animation art. If that era arrives, it is likely to be highlighted by films that are nothing like the Disney classics.

APPENDIX 1

CARING FOR YOUR COLLECTIBLES

Vintage animation art, particularly pieces made before 1951, when cels were still made of the highly flammable material cellulose nitrate, is extremely fragile. It is crucial that the collector be cognizant of the basics of preservation, handling, cleaning, framing, display, storage, and restoration.

First, a word of warning about those cellulose nitrate cels. In order to avoid the dangers of spontaneous combustion, these cels should be either framed or placed individually in closed metal containers, with no combustible materials, and stored in a cool, well-ventilated area, never simply stacked in a drawer. Even if framed, they should be removed from the frame for a few minutes every year to permit the resins and fumes to escape.

Now onto a more general consideration of the elements involved in caring for your collection.

LIGHT: For the protection of your cels, never hang them where they are exposed to direct sunlight, because ultraviolet radiation

rays can cause pigments to fade, soften, and/or crack and can also be harmful to both acetate and paper. Low-wattage, diffused light is highly preferable to picture lights or spotlights, halogen or fluorescent light.

TEMPERATURE: A cool temperature of between 55 and 72 degrees and moderate humidity provide the ideal environment. Like light, excessive heat can soften the paint on cels, and can also dehydrate and damage paper fibers. A stable environment of 40 to 50 percent humidity will prevent paint on cels from drying out (and cracking) and paper from becoming brittle. Humidifiers, hygrometers, and air conditioners are useful tools in keeping heat and humidity at optimal levels. Avoid hanging animation art in such areas as bathrooms and kitchens, as well as on exterior walls.

FRAMING: Cels should always be framed as soon as possible after acquisition to avoid wrinkling and cracking. Conservation-quality, acid-free mats and acid-free rag backing should be used to prevent discoloration. Animation art should be mounted behind UV-filtering glass; make sure that the art does not come in direct contact with the glass.

HANDLING AND CLEANING: Always hold unframed cels and drawings at the edges and never handle a cel with dirty or oily fingers—some experts wear white cotton gloves. The surface of a cel should not be touched, nor should water or any other liquid be used for cleaning. Similarly, do not spray any type of cleaner on the glass of a framed work, but rather spray a solution of warm water with a small amount of vinegar or lemon juice onto a soft cloth and carefully clean the glass, then dry with a second clean cloth. Make sure cels are not rolled or bent; if minor curling does occur, do not forcefully try to straighten the cel out. With works on paper, never use tape of any kind to repair a tear; do not

try to remove soil with an eraser; and do not write in ink on the back of the paper.

STORAGE: Unframed cels should not be stacked one on top of the other but should be stored vertically against an interior wall, with the largest ones closest to the wall. Also, do not place acetate or polyester sheets directly against cels or works on paper, to avoid sticking and static electricity. Given the detrimental effects of heat and humidity, it would be unwise to store animation art in such areas as attics, basements or cellars, or close to heat sources such as radiators. Items to be stored for an extensive period of time should not be wrapped in plastic or bubble-wrap. Works on paper should be kept as flat as possible, preferably in a file, covered with acid-free tissue.

RESTORATION: Opinions vary greatly when it comes to deciding whether or not to restore vintage animation art. Since animation art is so fragile, it is not surprising to find damaged vintage cels and backgrounds. Whether a flaw affects your enjoyment of the piece or its value enough to take it to a professional restorer is a matter of personal choice. If you do decide on restoration, choose a restorer as carefully as you would a personal physician; try to get a recommendation from at least one other collector and look at examples of the restorer's previous work.

APPENDIX 2

CARTOON STARS AND THEIR STUDIOS

ANDY PANDA	*Walter Lantz Studio*
ARCHIE	*Filmation Studio*
BABY HUEY	*Famous Studio*
BEANY AND CECIL	*Bob Clampett Studio*
BETTY BOOP	*Fleischer Studio*
BLUTO	*Fleischer Studio*
BORIS AND NATASHA	*Jay Ward Studio*
BOSKO	*Warner Bros., MGM*
BUGS BUNNY	*Warner Bros.*
BUZZY BUZZARD	*Walter Lantz*
CASPER THE FRIENDLY GHOST	*Famous Studio*
THE CAT IN THE HAT	*Chuck Jones Studio*
CHARLIE BROWN	*Bill Melendez/Lee Mendelson Studios*
CHILLY WILLIE	*Walter Lantz*
CHIP 'N' DALE	*Walt Disney*

DAFFY DUCK	*Warner Bros.*
DAISY DUCK	*Walt Disney*
DONALD DUCK	*Walt Disney*
ELMER FUDD	*Warner Bros.*
FELIX THE CAT	*Otto Messner Studio*
THE FLINTSTONES	*Hanna-Barbera*
FLIP THE FROG	*Ub Iwerks Studio*
FOGHORN LEGHORN	*Warner Bros.*
GARFIELD	*Paws, Inc.*
GEORGE OF THE JUNGLE	*Jay Ward Studio*
GERALD McBOING-BOING	*UPA Studio*
GOOFY	*Walt Disney*
THE GRINCH	*Chuck Jones Studio*
HECKLE AND JECKLE	*Terrytoon Studio*
HUCKLEBERRY HOUND	*Hanna-Barbera*
HUEY, DEWEY AND LOUIE	*Walt Disney*
THE JETSONS	*Hanna-Barbera*
JOSE CARIOCA	*Walt Disney*
KO-KO THE CLOWN	*Fleischer Studio*
KRAZY KAT	*Charles Mintz Studio*
THE LITTLE KING	*Van Beuren Studio*
LITTLE LULU	*Famous Studio*
LITTLE TOOT	*Walt Disney*
MAGILLA GORILLA	*Hanna-Barbera*
MARVIN MARTIAN	*Warner Bros.*
MICKEY MOUSE	*Walt Disney*
MIGHTY MOUSE	*Terrytoon Studio*
MINNIE MOUSE	*Walt Disney*
MR. MAGOO	*UPA Studio*
OLIVE OYL	*Fleischer Studio*
OSWALD THE LUCKY RABBIT	*Walt Disney, Walter Lantz*
PEPE LEPEW	*Warner Bros.*
PEGLEG PETE	*Walt Disney*

PINK PANTHER	*DePatie-Freleng Studios*
PLUTO	*Walt Disney*
POPEYE	*Fleischer Studio, Paramount*
PORKY PIG	*Warner Bros.*
RAGGEDY ANN AND ANDY	*Fleischer Studio*
ROAD RUNNER	*Warner Bros.*
ROCKY AND BULLWINKLE	*Jay Ward Studio*
RUFF 'N' REDDY	*Hanna-Barbera*
SCOOBY-DOO	*Hanna-Barbera*
SCREWY SQUIRREL	*MGM*
SIDNEY THE ELEPHANT	*Terrytoon Studio*
THE SIMPSONS	*Twentieth Century Fox Films*
SMURFS	*Hanna-Barbera*
SPEEDY GONZALEZ	*Warner Bros.*
SUPERMAN	*Fleischer Studio*
SYLVESTER	*Warner Bros.*
TASMANIAN DEVIL	*Warner Bros.*
TOM AND JERRY	*MGM*
TOM TERRIFIC	*Terrytoon Studio*
TWEETY BIRD	*Warner Bros.*
WILE E. COYOTE	*Warner Bros.*
WIMPY	*Fleischer Studio*
WOODY WOODPECKER	*Walter Lantz*
YOGI BEAR	*Hanna-Barbera*
YOSEMITE SAM	*Warner Bros.*

Sources and Resources

SOURCES

There are several options when it comes to buying and selling animation art (see Chapter 4). Probably the most reliable source for animation cels and drawings, particularly those at the top of the spectrum, would be one of the highly respected auction houses. Three of these stand above the others. They are:

Sotheby's
1334 York Avenue
New York, NY 10021
(800) 606-7000

Christie's East
219 East 67th Street
New York, NY 10021
(800) 395-6300

Howard Lowery
3818 W. Magnolia Blvd.
Burbank, CA 91505
(818) 972-9080

Annual subscriptions to these houses' profusely illustrated auction catalogues, which include estimated prices, are a worthwhile investment not only for bidding purposes but as invaluable research tools for the study of the field and the market.

On a day-to-day basis, more animation art changes hands through private galleries and stores than anyplace else. As discussed in Chapter 4, care should be exercised in selecting a dealer. And, while it is outside the scope of this book to recommend individual animation galleries, we reiterate that there is little risk involved in doing business with a gallery that has been pre-screened and approved by the Disney organization.

RESOURCES

INTERNET

The Internet is a new and burgeoning source of information and opportunity, expanding (and changing) so quickly that we hesitate to offer any specific sites. Type in a search topic such as "collecting animation art" and you will be besieged by data and colorful illustrations of cartoon art for sale. Here we would like to reemphasize the warning *caveat emptor*—as with any mail-order buying, evaluation and authentification are much more difficult when the item cannot be seen.

Among the more interesting animation art sites on-line at the time of writing:

- CELMAIL@the gremlin.com offers information on various animated film societies, selected galleries, recommended books, opportunities for e-mail dialogue, and such specific

data as the filmographies of Chuck Jones and Tex Avery. Weekly e-mails deal with various collecting issues.

- Vintage Ink and Paint offers a glossary of animation art terminology, animation organizations and publications, newsgroups of interest to the animation fan, and e-mailing lists.

- http://www.finetoon.com presents a guide to collecting animation art and a glossary of "toon terms."

- CA Animation gives a precis on collecting animation art.

There are scores of other websites, some of them devoted to one studio ("Disney animation" yielded 951 responses), others to such characters as the Flintstones and Felix the Cat.

Animation World, published by Animation World Network, is the first monthly Internet magazine devoted solely to the world of animation, although it is not specifically geared to collectors.

PERIODICALS

There are three basic kinds of subscribers to animation magazines: animation professionals, cartoon buffs, and collectors. The mix of editorial content in the magazines listed here varies, but all contain material of interest to collectors.

Animation Magazine
28024 Dorothy Drive
Agoura Hills, CA 91301

Cel Magic: Animation Collectors Quarterly
1124 Firehouse Alley
Sacramento, CA 95814

Collectors' Showcase
4099 McEwen Drive
Dallas, TX 75244

In Toon
P.O. Box 217
Gracie Station, NY 10028

StoryboarD
15 Middle Dunstable Road
Nashua, NH 03062

GLOSSARY

As the art of animation becomes more and more complex and diversified, it becomes more and more difficult to pin down precise definitions for its terminology. In fact, various auction houses and galleries use different terminologies, so that what might be considered or catalogued as a "key setup" by one house could be described as a "matching setup" by another. Therefore, the following glossary should be taken as a guideline to terms and not necessarily hard and fast definitions.

Animac A computer program that aids the animator in adjusting the timing of the action in a scene by enabling him or her to scan the drawings and then adjust the rate at which they are played back on the screen.

Animation Drawing A drawing, usually in pencil (sometimes colored pencil) on animation paper, from which the cel paintings photographed in production are traced. This is the key part of the

animation process in which the animator creates the design and movement of the characters. Dealers and auction houses sometimes refer to any production-related drawing on any kind of paper as an animation drawing.

Animation Paper A rectangular piece of paper with peg holes punched in the lower edge to hold animation drawings in register.

Art Props Background See *Reproduction Background.*

Background The painted artwork (usually in watercolor or tempera on paper) that forms the backdrop for the animated action of a scene over which a cel (or series of cels) is placed. Since there can be hundreds of cels photographed against a single background, there are far fewer backgrounds than cels made for a film. A *pan background* is an elongated, panoramic background made to accommodate extensive camera movements. Because of its rarity and complexity, it is highly prized by collectors. A *background drawing* or *layout* is a rough sketch serving as a model for a background painting and may or may not include indications of proposed action of animated characters. A *background color key* is a preliminary study—sometimes small, sometimes quite large—made to establish the color values for a given background.

Blue Sketch Following animation, a tracing is done that tracks the course of action of the characters. This is helpful to art directors and background artists in devising props and lighting.

CAPS The acronym for Disney's Computer Animation Production System, which facilitates the assembling of the various elements—backgrounds, animation, special effects, and computer-animated elements—into finished frames of film.

Cel Short for celluloid, a clear, chemically treated plastic on which the characters and other moving elements that make up an animated film are painted by studio artists, based on the animators' original pencil drawings. A cel usually represents the actions

of one character in one frame of the film. It takes at least 24 cels—
more when multiple characters are involved—photographed
against a painted background, for each second of screen time, or a
minimum of 1,440 cels per minute.

At first, cels were traced on the surface of clear celluloid sheets
with pen or brush and ink, then painted on the back with special
gum-based paints. These were designed for easy erasure, since
early cels were for the most part washed off to be reused in other
productions.

Until 1940, all cels were made of cellulose nitrate, an extremely
flammable and unstable material, susceptible to discoloration and
shrinkage with extended exposure to heat and light. The change to
cels made of the safer and more durable cellulose acetate was ini-
tiated with the production of Disney's *Fantasia* in 1940. The two
types can be distinguished by their differing thickness, hardness,
and color.

In the cel process, the invention of which has been attributed to
Earl Hurd, a line drawing is either hand-inked or xerographically
transferred onto the acetate, after which the image is painted on
the back of the sheet. Cels come primarily in two standard sizes:
about 12 by 10 inches (referred to as a 12-field) or 16 by 12 (a 16-
field). Every vintage production cel is a unique work of art.

Cel Setup The combination of one or more cels overlaid on a
background, sometimes including overlay cels depicting fore-
ground elements such as vegetation or pieces of furniture. Unless
specifically described as a matching cel setup—in an auction cata-
logue, for example—there is no assurance that a multiple cel setup
came from the same frame of the film described.

CGI Computer-generated imagery, the elements of a film created
by computer animators and technicians. Creating animation with
the computer is quite different from using the computer as a pro-
duction tool (see CAPS). The major animation producers rarely
use CGI, and then only to deal with specific situations—such as

the stampede in *The Lion King,* which would be almost impossible to animate by traditional methods.

Character Animator An artist who develops a particular character or characters. In effect, character animators are like actors with pencils, bringing their charges to life through their draftsmanship. They are the stars of the animation industry.

Cleanup Drawing The ultimate refining by a cleanup artist of an animator's rough expressive drawing into the smooth finished one that will be scanned and painted to form the final color cel.

Color Key A small sketch that indicated the coloration of a sequence in the final film. (See *Background.*)

Color Model Cel A color reference on celluloid for the inkers and painters during the preparation of a film. They usually have the words *color model* on the bottom of the cel.

Comparative Size Sheet A depiction of the characters next to one another to illustrate their relative dimensions.

Concept Art or Drawing Also called *inspirational art,* these preliminary sketches and paintings in pencil, watercolor, pastel, or crayon are made early in a production to suggest the settings for various plot elements, for example, or to establish the overall tone or atmosphere of a scene.

Copy Background See *Reproduction Background.*

Courvoisier Background A setup prepared either in or outside the Disney Studio and marketed by the Courvoisier Gallery of San Francisco between 1937 and 1946.

Dye-Transfer Print A multiple produced in limited quantities by a special process that yields high-quality, brilliantly colored prints. Those produced by Disney were originally packaged in an inscribed mat with a Walt Disney Productions label.

Exposure Sheet The document that tracks all the drawings and camera movements and settings in an animated scene. Often abbreviated to *X-sheet.*

Extremes The animators' drawings that show the beginning and end of an action or sequence.

Frame A single photograph on a strip of film. There are 16 frames per foot and when the film is projected, 24 frames are viewed each second.

Hand Inking Until the late 1950s, this process was used universally to create the outlines on cels. The blank, clear cel was laid over a drawing, and the drawing was then traced onto the cel with special pens and inks. Hand inking is in limited use today.

Hand-Prepared or Non-Production Background A background painting, usually executed in watercolor, made for the specific purpose of enhancing the appearance of the characters on a cel.

In-betweens The drawings between the animators' key drawings of a sequence, executed by assistants called in-betweeners.

Inspirational Art See *Concept Art.*

Key Drawing, Key Background, Key Setup A strategic drawing or painting that establishes the look of a scene, or the pairing of a production cel and master background as they will actually appear in the film.

Layout Renderings, usually in pencil, that establish the basic composition of a scene, showing the details of the background exactly as they will appear on screen. These are essentially the charts from which animators, background artists, and camera operators work. Some layouts include schematic representations of the characters as they will appear against the background, showing their route through the scene. Also found on some layouts are frame lines, identifying camera movements such as pans or zooms.

Limited Edition Cel Cels created in limited numbers specifically for the collectors' market. They are generally inked from original animation drawings, but may or may not be exact replicas of production cels. In most cases they are numbered to identify the total amount of cels in the edition and the individual number of the particular cel, and display a studio seal. When there is no limit on the number produced, these are called *scene cels.*

Litho or Print Background The production of a background by any of several printing processes. Those issued by Disney and sold at their parks are called either *litho backgrounds* or *Disneyland backgrounds.*

Master or Production Background An original painted background that actually appeared as a setting in the final, released version of a film. Cels and backgrounds that appear together on screen are referred to as *matching.*

Model Sheet A single sheet of paper on which several pencil or colored drawings display various poses of a character or group of related characters. The original sheet would then be copied and distributed to the animators to be used as a guide to ensure consistency. Most often the model sheets that come on the market are these Photostat reproductions produced in-studio, but occasionally a hand-drawn original surfaces. These are highly desirable.

Multi-cel Setup Two or more cels stacked together to present a single image; considered a single piece of artwork.

Music Room Songs are so important to the Disney animated features that in Walt Disney's day the director's office was always supplied with a piano and referred to as the music room. It was here that songwriters, artists, and storymen got together for key production meetings. Paintings and drawings prepared for these meetings were sometimes referred to as *music room art.* For the most part, though, these drawings could equally be referred to as *conceptual art* or *storyboard art,* depending upon their specific function.

Overlay Additional artwork placed on top of a background or layout to illustrate an object in the foreground.

Preliminary Background A background created during the production process but not used in the final film.

Production Background See *Master Background.*

Production Cel A cel that is placed over a background painting and photographed to become a frame in the completed film. When each of these photographs is projected in rapid succession, the illusion of motion is achieved. Unique in that it represents an actual segment of an animated film, a production cel will have peg holes at the bottom and also a number or series of identifying numbers.

Publication Background A background taken from a book or other publication and used to enhance a cel.

Publicity or Promotional Cel A cel not actually used in a film but created solely for publicity, promotional, or display purposes. It may be inked from an original drawing or may depict an idealized scene. Publicity cels are usually produced in multiples.

Reproduction or Copy Background Since there are many fewer master backgrounds in proportion to available cels, some studios now release their cels against replicated backgrounds. These can be high-quality laser copies or offset lithographs of the master background, prepared at the studio. Also called a *studio* or *art props background* since, at Disney in particular, they were prepared by the Art Props Department.

Scene A segment of action that consists of a complete idea.

Scene Cel See *Limited Edition Cel.*

Sericel A limited edition cel produced by a silkscreen process.

Setup The combination of a background with one or more cels.

Storyboard A sequence of pencil sketches pinned to a board in consecutive order to tell the plot of the story visually, in comic-

book style. A storyboard serves as a preliminary reference guide for the animators and others working on the film. Each of the sketches is referred to as a *storyboard drawing*.

Studio Background See *Reproduction Background*.

Title Card A special cel and background setup used for the titles or credits of an animated movie.

Trimmed Cel A cel known to have been cut down from its original size, then attached directly to a background or new cel.

Xerography The process initiated in the late 1950s by which the animator's drawing is transferred to a cel by a xerography machine, replacing hand inking. In general, xeroxed outlines are thicker, softer, and sketchier than those drawn by hand. Because of the speed and cost effectiveness of the process, it has rendered hand inking virtually obsolete. *101 Dalmations,* released in 1961, was Disney's first animated feature to use the xerography process.

SELECTED BIBLIOGRAPHY

In the last few years, a plethora of excellent books has appeared on the art of animation, greatly adding to the storehouse of information available to the collector. In our opinion, the best general introductions to the subject are Charles Solomon's *Enchanted Drawings: The History of Animation,* published by Knopf, and Leonard Maltin's *Of Mice and Magic: A History of American Animated Cartoons,* published by Plume. The following list includes other more specialized books, ranging from studio histories to memoirs to volumes of practical advice for collectors, that we consider useful.

Adamson, Joe. *Tex Avery: King of Cartoons.* Da Capo Press, New York, 1975.

——. *The Walter Lantz Story.* G. P. Putnam's, New York, 1985.

——. *Bugs Bunny: Fifty Years and Only One Grey Hare.* Henry Holt, New York, 1990.

———. *The Flintstones: A Modern Stone Age Phenomenon.* Turner Publishing, Atlanta, 1994.

Arnold, Ken. *Caring for Your Collectibles.* Krause Publications, Iola, WI, 1996.

Bain, David, and Bruce Harris. *Mickey Mouse: Fifty Happy Years.* Harmony Books, New York, 1977.

Barbera, Joe. *My Life in 'Toons: From Flatbush to Bedrock in Under a Century.* Turner Publishing, Atlanta, 1994.

Beck, Jerry. *The Fifty Greatest Cartoons.* Turner Publishing, Atlanta, 1994.

Beck, Jerry, and Will Friedwald. *Looney Tunes and Merrie Melodies: A Complete Illustrated Guide to the Warner Bros. Cartoons.* Henry Holt, New York, 1989.

———. *I Tawt I Taw a Puddy Tat.* Henry Holt, New York, 1991.

Bendazzi, Giannalberto. *Cartoons: One Hundred Years of Cinema Animation.* University of Indiana Press, Bloomington, 1995.

Blanc, Mel, and Philip Bashe. *That's Not All, Folks.* Warner Books, New York, 1988.

Blitz, Marcia. *Donald Duck.* Harmony Books, New York, 1979.

Brion, Patrick. *Tom and Jerry: The Definitive Guide to the Animated Adventures.* Harmony Books, New York, 1990.

Canemaker, John. *The Animated Raggedy Ann and Andy: An Intimate Look at the Art of Animation.* Bobbs-Merrill, New York, 1977.

———. *Tex Avery: The MGM Years.* Turner Publishing, Atlanta, 1996.

———. *Before Animation Begins: The Art and Lives of Disney Inspirational Sketch Artists.* Hyperion, New York, 1996.

———. *Winsor McCay: His Life and Art.* Abbeville Press, New York, 1987.

———. *Felix: The Twisted Tale of the World's Most Famous Cat.* Pantheon Books, New York, 1991.

———, ed. *Storytelling in Animation: The Art of the Animated Image.* Samuel French, New York, 1988.

Canemaker, John, and Robert E. Abrams. *Treasures of Disney Animation Art.* Abbeville Press, New York, 1982.

Carbaga, Leslie. *The Fleischer Story.* Nostalgia Press, New York, 1976.

Crafton, Donald. *Before Mickey: The Animated Film 1898–1928.* MIT Press, Cambridge, 1982.

Culhane, John. *Walt Disney's "Fantasia."* Abrams, New York, 1983.

———. *Disney's Aladdin: The Making of an Animated Film.* Hyperion, New York, 1992.

Culhane, Shamus. *Talking Animals and Other People: The Autobiography of One of Animation's Legendary Figures.* St. Martin's Press, New York, 1986.

———. *Animation from Script to Screen.* St. Martin's Press, New York, 1990.

Edwards, R. Scott, and Bob Stobener. *Cel Magic: Collecting Animatiion Art.* Laughs Unlimited, 1991.

Field, Robert D. *The Art of Walt Disney.* Macmillan, New York, 1942.

Finch, Christopher. *The Art of Walt Disney: From Mickey Mouse to the Magic Kingdoms.* Harry N. Abrams, New York, 1973, 1995.

———. *Walt Disney's America.* Abbeville Press, New York, 1978.

———. *The Art of the Lion King.* Hyperion, New York, 1994.

Friedwall, Will, and Jerry Beck. *The Warner Bros. Cartoons.* Scarecrow Press, Metuchen, NJ, 1981.

Grossman, Gary H. *Saturday Morning.* Dell, New York, 1981.

Grant, John. *Encyclopedia of Walt Disney's Animated Characters from Mickey Mouse to Aladdin.* Hyperion, New York, 1993.

Hahn, Don. *Disney's Animation Magic,* Disney Press, New York, 1996.

Halas, John. *Masters of Animation.* Salem House, Topsfield, MA. 1987.

Heide, Robert, and John Gilman. *Cartoon Collectibles: 50 Years of Dimestore Memorabilia.* Doubleday, New York, 1983.

Hollis, Richard, and Brian Sibley. *Walt Disney's Mickey Mouse: His Life and Times.* Harper & Row, New York, 1986.

———. *The Disney Studio Story.* Crown, New York, 1988.

———. *Walt Disney's Snow White and the Seven Dwarfs: The Making of the Classic Film.* Hyperion, New York, 1994.

Jones, Chuck. *Chuck Amuck, The Life & Times of an Animated Cartoonist.* Farrar, Strauss & Giroux, New York, 1990.

———. *Chuck Reducks: Drawing from the Funny Side of Life.* Warner Books, New York, 1996.

Justice, Bill. *Justice for Disney.* Tomart, 1992.

Kanfer, Stefan, *Serious Business: The Art and Commerce of Animation in America from Betty Boop to Toy Story.* Scribner, New York, 1997.

Kinney, Jack. *Walt Disney and Other Assorted Characters: An Unauthorized Account of the Early Years at Disney's.* Harmony Books, New York, 1988.

Krause, Martin, and Linda Witkowski. *Snow White and the Seven Dwarfs.* Hyperion, New York, 1994.

Lenberg, Jeff. *The Encyclopedia of Animated Cartoons.* Facts on File, New York, 1991.

Lotman, Jeff. *Animation Art, The Early Years 1911–1953: A Visual Reference for Collectors.* Schiffer Publishing, Atglen, PA, 1995.

Maltin, Leonard. *Of Mice and Magic: A History of American Animated Cartoons.* McGraw-Hill, New York, 1980.

———. *The Disney Films: From Snow White and the Seven Dwarfs to Pocahontas.* Hyperion, New York, 1995.

Merritt, Russell, and J. B. Kaufman. *Walt in Wonderland: The Silent Films of Walt Disney.* Johns Hopkins University Press, Baltimore, 1993.

Munsey, Cecil. *Disneyana: Walt Disney Collectibles.* Hawthorne, New York, 1973.

Peary, Gerald, and Danny Peary. *The American Animated Cartoon.* E. P. Dutton, New York, 1980.

Rebello, Stephen. *The Art of the Hunchback of Notre Dame.* Hyperion, New York, 1996.

———. *The Art of Hercules: The Chaos of Creation, Vol. I.* Hyperion, New York, 1997.

Schneider, Steve. *That's All Folks: The Art of Warner Bros. Animation.* Henry Holt, New York, 1988.

Sennett, Ted. *The Art of Hanna-Barbera: Fifty Years of Creativity.* Viking Studio Books, New York, 1989.

Shull, Michael S., and David E. Wiet. *Doing Their Bit: Wartime Animated Short Films, 1939–45.* McFarland, 1987.

Smith, Dave. *Disney A to Z: The Official Encyclopedia.* Hyperion, New York, 1996.

Smoodin, Eric. *Animating Culture: Hollywood Cartoons from the Sound Era.* Rutgers University Press, New Brunswick, NJ, 1993.

Solomon, Charles. *Enchanted Drawings: The History of Animation.* Alfred A. Knopf, New York, 1989.

Thomas, Bob. *Walt Disney: An American Original.* Simon and Schuster, New York, 1976; Hyperion, 1994.

———. *Disney's Art of Animation: From Mickey Mouse to Beauty and the Beast.* Hyperion, New York, 1991.

Thomas, Frank, and Ollie Johnston. *Disney Animation: The Illusion of Life.* Abbeville Press, New York, 1981.

Tumbusch, Tom. *Tomart's Illustrated Disneyana Catalog and Price Guide.* Wallace-Homestead Book Company, Radnor, PA, 1989.

Weist, Jerry. *Original Comic Art Identification and Price Guide.* Confident Collector Series, Avon Books, New York, 1992.

INDEX